IMAGES
of America

MARYLAND'S SKIPJACKS

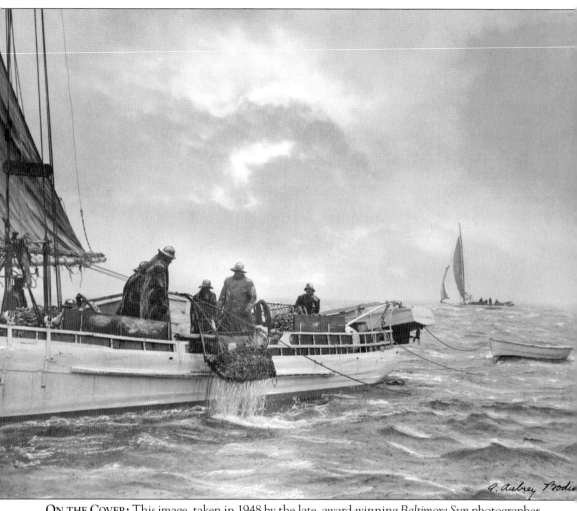

ON THE COVER: This image, taken in 1948 by the late, award-winning *Baltimore Sun* photographer A. Aubrey Bodine, captures both the beauty of the skipjacks under sail and the harsh conditions an oyster boat crew worked in. The *Maggie Lee* in the foreground and the *Lucy Tyler* in the distance are dredging for oysters under cold, wet winter skies on the Choptank River. The *Maggie Lee* was built in 1903 and was finally broken apart in 2006 after efforts to save her failed. The fate of the *Lucy Tyler* is unknown. (Photograph by A. Aubrey Bodine, © Jennifer Bodine; Courtesy of www.AAubreyBodine.com.)

IMAGES
of America

MARYLAND'S SKIPJACKS

David Berry

ARCADIA
PUBLISHING

Published by Arcadia Publishing
Charleston SC, Chicago IL, Portsmouth NH, San Francisco CA

Printed in the United States of America

Library of Congress Catalog Card Number: 2007938755

For all general information contact Arcadia Publishing at:
Telephone 843-853-2070
Fax 843-853-0044
E-mail sales@arcadiapublishing.com
For customer service and orders:
Toll-Free 1-888-313-2665

Visit us on the Internet at www.arcadiapublishing.com

To Chris, Jason, Julie, and Mom,
who have inspired me more than they will ever know.

CONTENTS

ACKNOWLEDGMENTS

This book could not have been possible without the kind assistance of Pete Lesher, curator of collections at the Chesapeake Bay Maritime Museum; Robert Hurry, registrar at the Calvert Marine Museum; the people at Chesapeake Heritage Conservancy; the captain of the *Martha Lewis*, Greg Shinn; Amy Kehring; Jennifer Bodine; and all the people who value skipjacks. They provided not only valuable assistance in obtaining the images, but also their skipjack expertise. I would also like to thank Lauren Bobier at Arcadia Publishing for her faith in allowing me the opportunity to assemble this volume.

Skipjacks would have disappeared entirely without the efforts of hundreds of Marylanders who invested time and money in saving a part of their history. We thank them for their vision and persistence.

INTRODUCTION

You could feel the wind shifting from the south to become more westerly. A quick glance showed the water off the port side darkening as the wind velocity increased. An unseasonably warm November day was about to turn cold. The captain turned the bow farther away from the wind. You could hear the 50-foot Douglas fir boom creaking as the sails adjusted to the slight change of course. The crew on the port side was still sorting. The crew on the starboard side was waiting for the signal to lower the basket. The two previous passes had almost filled a bushel basket. This would be the last lick before heading for the dock, and we wanted to make it a productive one.

The captain gunned the dredge motor. We lifted our basket over the roller, letting the steel cable spool out. A quick feel of the cable indicated we were over the bed. We would bring oysters up this time, not mud. The skipjack *Martha Lewis* was back doing what she had been built to do, harvesting oysters from the shallow bottom of the Chesapeake Bay, just as hundreds of skipjacks have done for the past century and a half.

Oysters have been harvested from the Chesapeake Bay since before the first English settlers arrived. The native, indigenous tribes had been aware of the bounty that came from its waters for centuries. John Smith, the first Englishman to document his travels around the bay, noted the size and number of oyster's reefs he encountered during his voyage of 1608. He wrote that they were "as thick as stones." Other early explorers found individual oysters measuring 13 inches across, large enough that they would have to be cut in half to be eaten.

Until dredging under sail was legalized at the end of the Civil War, oysters were caught in small quantities by tonging, literally raising them from the bottom using long-handled tongs. The demand for oysters had increased to the point where serious money was to be made. Mass harvests were conducted using large schooners that could catch and carry hundreds of bushels. Many of these vessels came to the Chesapeake Bay from New England and New York, and Marylanders were concerned that outsiders were taking all the oysters.

The bugeyes were introduced to compete against the larger ships. These were tender, hard to sail boats built by joining poplar or pine logs together. They could work shallow water, catching oysters that were beyond the reach of the deepwater boats from Long Island and Cape Cod, but the bugeyes tended to be easily overpowered by the fierce, winter winds that blow across the Chesapeake. Their narrow hulls limited what they could carry.

The oyster harvests continued to increase from three million bushels in the early 1860s when tonging was the only method allowed to more than nine million bushels in the later part of that decade after dredging was introduced. Maryland and Virginia created oyster police forces in 1868 to control illegal catches, but by the time the first official oyster survey, called the Winslow Survey, was conducted in 1877, the catch had grown to more than 10 million bushels a season. The survey found that the oysters were doomed unless harvests were further limited. This only created more activity. Fifteen million bushels were raised in 1884, and the estimated 3,000 oyster fishermen of 1860 had grown to over 21,000 by the end of the 19th century.

The watermen were aware that the oyster population was being depleted but felt it was their role to catch them all before they were gone. John R Wennerstein in his classic book, *The Oyster Wars on the Chesapeake Bay*, quotes a waterman, "Get it today. Leave it till tamar, somebody else'll get it." The states didn't always agree with this attitude, and wars were fought between states, between the marine police and the watermen, and between boats. Twelve men were killed during oyster fights in 1889 alone.

The skipjack was created in the middle of this frenzy. The two-masted bugeyes were proving to be too expensive to build, costing close to $800 in 1884, and could only carry 200 to 300 bushels of oysters. The skipjacks were larger. The *Rebecca T. Ruark*, built in 1886 and now the oldest surviving skipjack, is 53 feet long and 17 feet across. They were a simple, one-mast design that could be put together cheaply by unskilled labor and could hold more than 500 bushels on their large decks. A skipjack, like a bugeye, was built to reach shallow waters. The *Rebecca T. Ruark* only needs four feet, six inches of water thanks to her flat, V-shaped bottom. She can lower her centerboard to nine feet, seven inches for more stability when she is in deeper water.

The wooden skipjacks appear awkward sitting still, but under sail, they come to life. The large mainsail and smaller jib work together in the wind to create the torque necessary to pull the heavy dredge baskets behind the stern. They move like freight trains across the oyster reefs, but they are a handful to maneuver. The skipjack *Martha Lewis*, for example, weighs more than eight tons. Plenty of advanced notice and room is required when her captain needs to tack, or turn her bow through the wind. A good skipjack captain knows his boat and how to maximize her productivity. They know the bottom under their keel like a farmer knows his fields. They make multiple passes over the oyster beds, turning just before the dredge baskets hit mud.

Skipjacks continued to be constructed at a steady pace from the 1890s until the beginning of World War I. Oyster harvests continued to decline, leveling off around three million bushels a year in the 1930s. Skipjack building saw a small resurgence in the years immediately after World War II, but the remaining oysters were falling victim to unforeseen forces—Dermo and MSX—diseases probably introduced when foreign oysters were planted in the Chesapeake Bay. Maryland changed the dredging law in 1967 to allow the skipjacks to use their engine-driven push boats two days a week, but the industry is effectively dead. The 2006 harvest was 273,000 pounds or around 50,000 bushels.

Skipjacks were built cheap and were never meant to last. As the oysters died, more and more of these classic boats were pulled into shallow waters to rot away. Marylanders began to realize what was being lost. Estimates vary, but in 2007, it is believed that between 25 and 37 skipjacks survive. Many still sail, but only six went dredging during the 2005–2006 season.

Even these figures are misleading. The *Martha Lewis* was built along with two sister skipjacks, the *Lady Katie* and the *Rosie Parks*, in 1955 and 1956. They would be the last three built with the expectation that they would be working boats. Five have been built since 1979 and were intended to honor and preserve the tradition.

That leaves an estimated 963 skipjacks unaccounted for. They have disappeared back into the mud along the Eastern Shore. A captain worked the boat until she was too expensive to repair, left her to rot or sink, built another, or changed careers. Records on their final resting spots are incomplete, and most have been lost to history.

Parallel efforts are taking place. The State of Maryland, along with many private institutions, has tried several methods of restoring the oyster population. A number of reefs remain off-limits for harvesting or are restricted to tonging alone. The state also recognized the historical value of the skipjacks in 2000 when they named the vessels the official boats of Maryland. The *Rebecca T. Ruark* and the *Hilda M. Willing* are both National Historic Landmarks.

Time and money have been made available by the state and federal governments, nonprofit organizations such as the National Historic Trust, private donors, and corporate sponsors such as Black and Decker to restore and maintain the skipjacks. The *Martha Lewis* was brought to Havre de Grace, Maryland, in 1994, restored, and continues to sail and dredge. The Chesapeake Maritime Museum's Skipjack Restoration Project has worked on nine skipjacks since 2002. An earlier project, the *E. C. Collier* is a land exhibit at the museum.

The winds across the Man of War shoals near the mouth of the Patapsco River continued to increase as the *Martha Lewis* made her final lick across the oyster rock. Low, gray rain clouds scuttled across what had been a bright blue sky an hour before. Oyster dredging weather—cold, wet, and breezy—was on the horizon. The dredge basket came up over the roller with more keepers, oysters over three inches, than any of the previous hauls. The captain turned her toward home as the crew trimmed in the powerful sails. The working life of at least one skipjack continues.

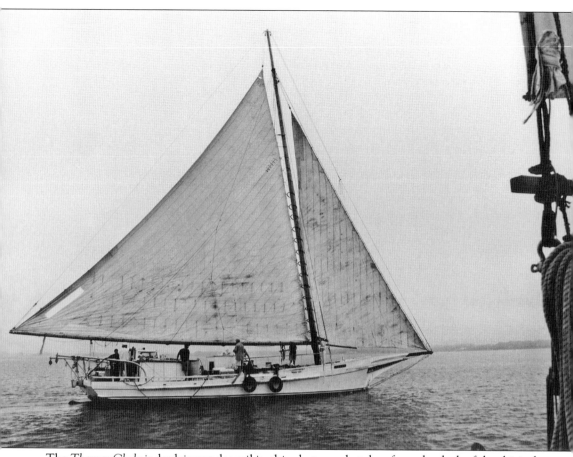

The *Thomas Clyde* is dredging under sail in this photograph, taken from the deck of the skipjack *Martha Lewis*. She was constructed in Oriole, Maryland, in 1911 and was restored through a program at the Chesapeake Bay Maritime Museum. She did not dredge over the most recent season, but she did win the 47th annual skipjack race held at Deal Island in September 2007. The 1994 restoration of the *Martha Lewis* was done in Havre de Grace, Maryland. The terms of the agreement that gave the *Martha Lewis* to the Chesapeake Heritage Conservancy Program said that she must continue to dredge for oysters each year. She completed her 52nd year of oystering in December 2007. (Photograph by Amy Kehring.)

One

A LIVING HISTORY

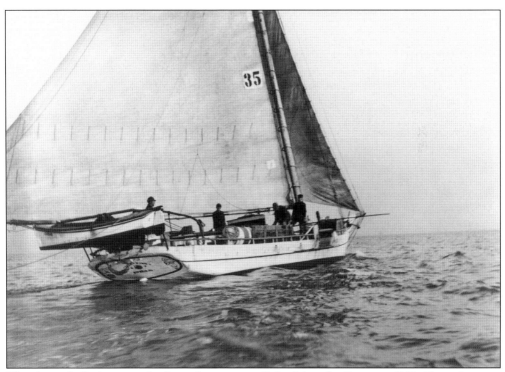

The skipjack *Catherine* is dredging for oysters off the Magothy River in 1937. Skipjacks were born in the late 1800s in response to the first slump in oyster populations, which encouraged the State of Maryland to change the laws regarding harvesting so it could only be done under sail. The large schooners from New England and New Jersey were coming to the Chesapeake Bay because their native oyster populations had been depleted, but the schooners could not reach many spots on the shallow Chesapeake Bay. (Photograph by Leonard C. Rennie; Courtesy of Calvert Marine Museum.)

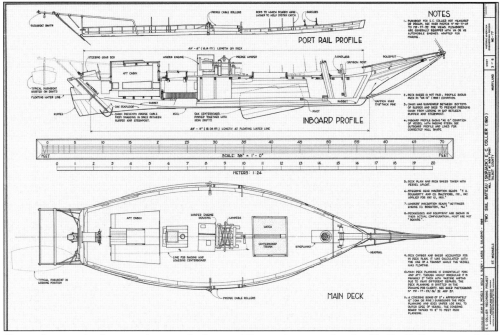

Skipjacks were built around a simple design. These plans are for the *E. C. Collier*, one of the many skipjacks built on Deal Island. She was built around 1910 by G. W. Horsemen and dredged for many years before her restoration at the Chesapeake Bay Maritime Museum. The plans were created at the time of that restoration, but Horsemen would have probably had no drawings and constructed her totally from scratch. The Eastern Shore builders knew what made a good, stable boat and used simple formulas to achieve their goal. The engine and a few metal fittings were about the only items on a skipjack that were not found locally. (Courtesy of the Library of Congress.)

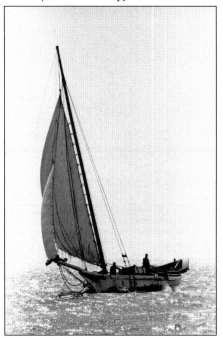

A skipjack is making her way upwind under full sails. Skipjacks may have been named for the bonita, a fast-swimming fish known by the slang name "skipjack." The skipjack tuna is another possibility. There is even a school of thought that says skipjack was an archaic English word that meant inexpensive but useful servant. The original skipjack was probably built in Crisfield, Maryland, along the Eastern Shore, but the center of activity moved farther north to Deal Island. Dozens of boats were constructed in the villages around the island, but places such as St. Michaels, Cambridge, and a number of Virginia towns saw their share of skipjack building. The greatest numbers were launched in the 30 years between 1890 and 1920. (Courtesy of the Chesapeake Bay Maritime Museum.)

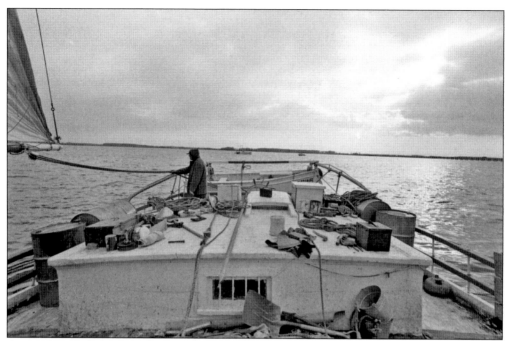

An unidentified skipjack is sailing downwind under the main sail alone. Bugeyes were the first sail craft designed to dredge for oysters, but they were expensive to build. Skipjacks were cheaper to construct. The correct name for skipjack-styled vessels is the two-sail bateau. As they evolved, "skipjack" began to mean the sail rig consisting of one mast and two sails, and "bateau" was used to describe the flat-bottom hulls. (Courtesy of the Chesapeake Bay Maritime Museum.)

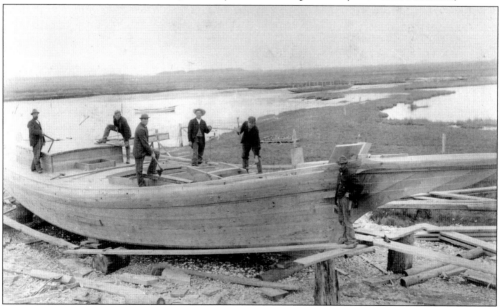

The skipjack *Annie Bennett* is being built at John Branford's shipyard on Fishing Island, Maryland, around 1898. Skipjacks are wooden boats using locally available materials: Douglas fir, loblolly pine, yellow pine, and tulip poplar. Boat builders could put one together in a short period of time. (Courtesy of the Dorothy E. Brewington Collection, Calvert Marine Museum.)

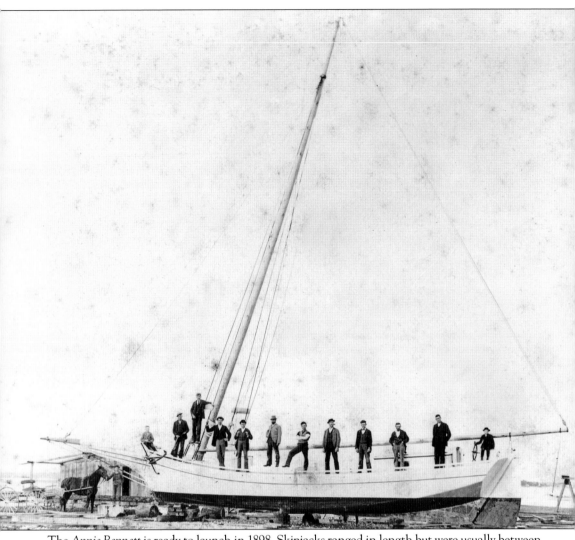

The *Annie Bennett* is ready to launch in 1898. Skipjacks ranged in length but were usually between 40 and 60 feet on deck with the overall length extended by the bow sprit on the front of the boat. The length on deck was determined by the size of the tree they found to make a good, straight mast. Mast height is equal to the length on deck plus the beam, or width. (Courtesy of the Dorothy E. Brewington Collection, Calvert Marine Museum.)

The skipjack *Martha Lewis* is moving across the water under full sail. Skipjacks are a sloop-rig with one mast and two sails; a large, loose-footed mainsail; and a self-tending jib or foresail. This combination gives the skipjack power to dredge, even in light winds, and requires a minimum number of crew to operate the boat, usually less than a half a dozen men. (Courtesy of Chesapeake Bay Maritime Museum.)

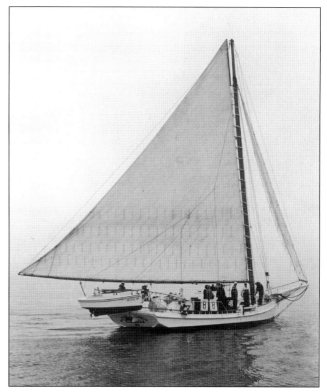

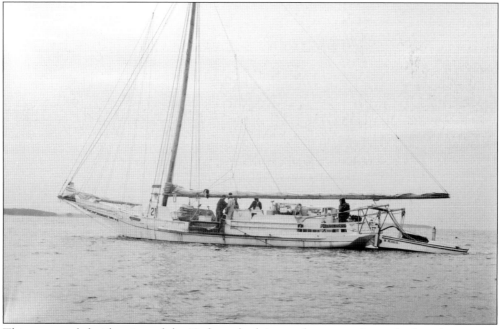

This port, or left-side, view of the *Kathryn* dredging under power shows the long boom on a skipjack. The boom on a skipjack is the same length as the boat is on deck. It will extend beyond the stern of the boat, allowing large mainsails to be used. Bigger main sails mean more power and acceleration. (Courtesy of the Library of Congress, American Memories.)

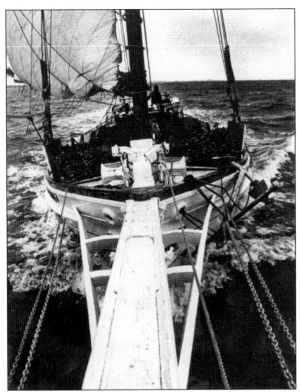

This unidentified skipjack is returning to port with a full load of oysters. The photograph was taken from the end of the long bow sprit. The bow sprit is as long as the vessel's beam, the widest part of the hull. This extra length allows the foresail, or jib, to be self tending. It does not require crew to move it past the mast as the boat turns. (Courtesy of the Calvert Marine Museum.)

Skipjacks are simple boats, but their builders took pride in the details. The wooden hoops that attached the mainsail to the mast had to be bent and hand fitted. The front edge of the mainsail is laced to the hoops, which slide up the mast when the sail is raised. (Courtesy of the Chesapeake Bay Maritime Museum.)

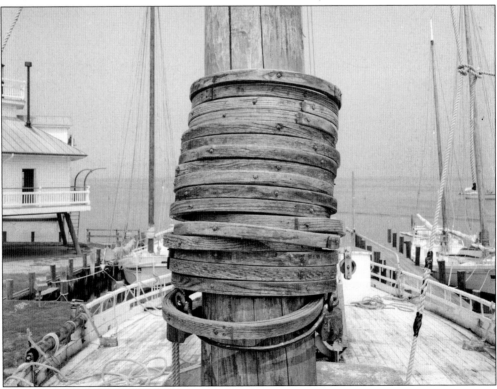

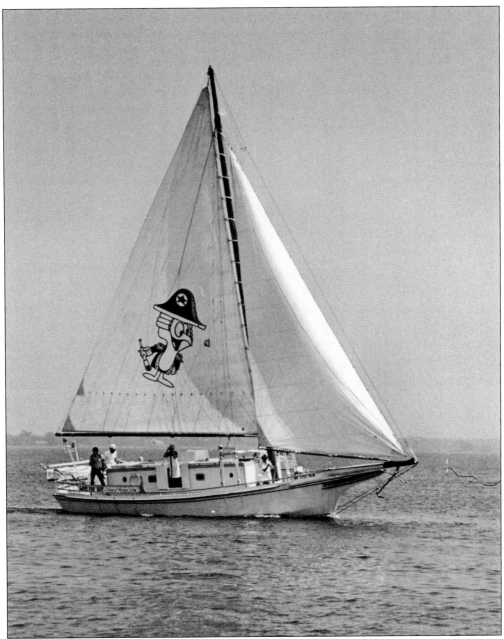

A skipjack is under sail with a whimsical captain on board. The size of the sails can be clearly seen in this view. The mast is under considerable pressure when the sails are raised and the wind is blowing. The terms used to describe the parts of a skipjack and its sails come from the days when the square-rigged warships of Great Britain ruled the seas. (Courtesy of the Chesapeake Bay Maritime Museum.)

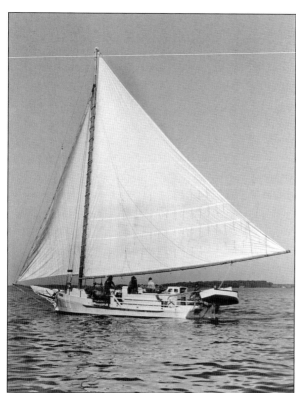

The mast on a skipjack is equal in height to the boat's width at the beam and length on the deck added together. The builders only had to find one acceptable tree for a skipjack instead of the multiple ones needed for other boat styles, such as bugeyes. (Courtesy of the Chesapeake Bay Maritime Museum.)

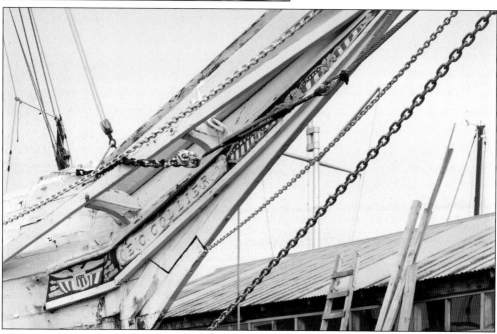

These are the hand-carved tailboards of the *E. C. Collier*. The name of a skipjack usually honored a female member of the first captain's family, or perhaps the captain himself. The patriotic theme was common on skipjacks. The various chains, called bob stays, are rigging to hold the bow sprit stable. (Courtesy of the Library of Congress.)

The oyster is the reason skipjacks came into being. There is nothing better than a raw, freshly caught Chesapeake Bay oyster. You can taste the salt from the water it was caught in. The oyster was the cash crop of Maryland and so important to the economy of the Chesapeake Bay that wars were fought over them. The long-running Oyster War between Maryland and Virginia was one of the issues addressed by the Constitutional Convention of 1787. (Photograph by Amy Kehring.)

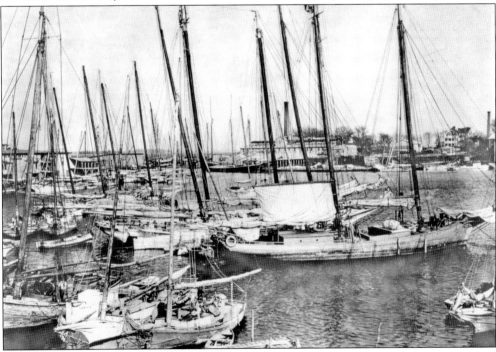

The harbor at Cambridge, Maryland, filled with various workboats waiting to go out in search of oysters. There are schooners, skipjacks, and bugeyes at the dock. The W. G. Winterbottom and Company oyster packinghouse is in the background. Hundreds of boats would leave ports on both sides of the Chesapeake Bay when the season opened on the first day of November. (Courtesy of the National Fishery Commission; credit: Frederick Tilip Collection, Calvert Marine Museum.)

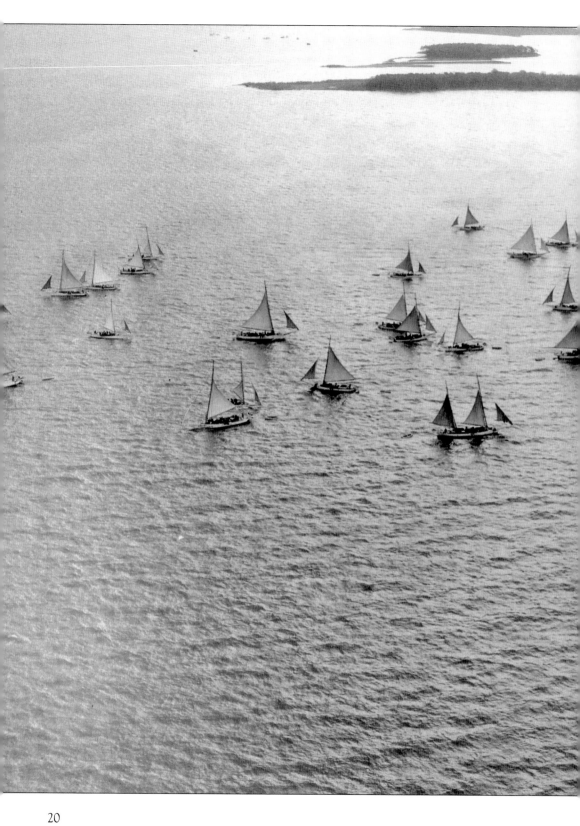

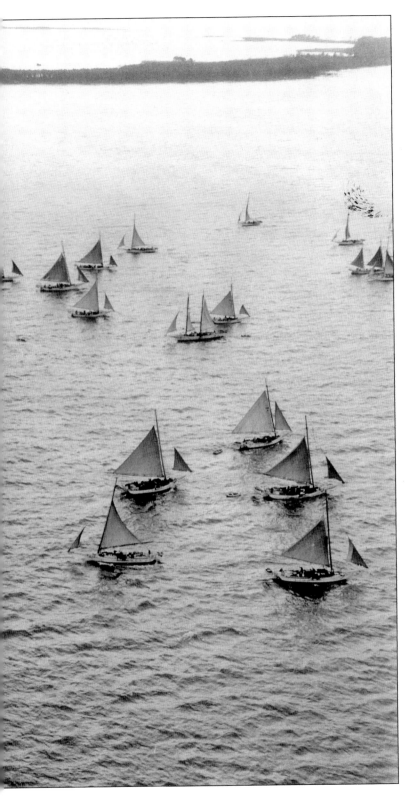

The skipjack fleet is dredging off of Poplar Island in 1950. Poplar Island, now being restored to its original size through the use of dredge spoils from the shipping channels, is near the three main Eastern Shore locations where the majority of the skipjacks were built: Crisfield, Deal Island, and Tilghman Island. There are bugeyes dredging along side of the skipjacks in this photograph. Bugeyes were the vessels that preceded the introduction of the skipjacks. They continued to be used but were expensive to build, using too much material to be cost effective. Skipjacks soon outnumbered the bugeyes on the Chesapeake Bay. (Courtesy of the Library of Congress.)

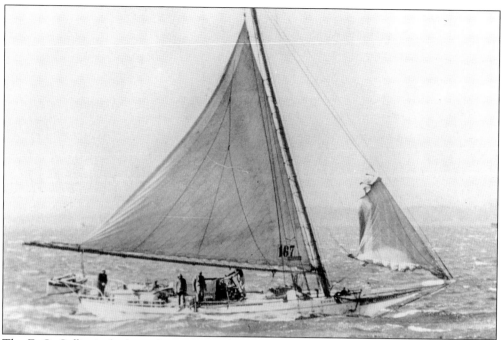

The *E. C. Collier* is dredging for oysters under sail. Capt. John Smith explored the Chesapeake Bay in 1608 and reported seeing oysters the size of dinner plates. The legal size in 2007 is three inches across. Early efforts to save the oysters by introducing ones from foreign waters may have been an unseen contributor to their decline. (Courtesy of the Elgin A Dunnington Jr. Collection, Calvert Marine Museum.)

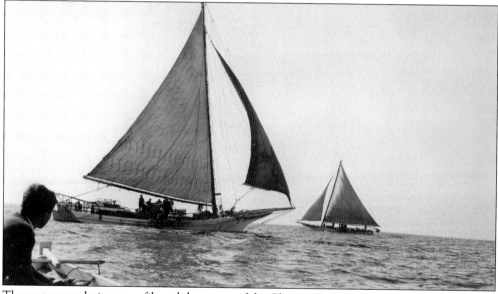

The oyster population once filtered the waters of the Chesapeake Bay every two days. The impact of over-harvesting and disease has been so severe that it now takes a full year for the remaining oysters to filter the water. The *E. C. Collier*, built on Deal Island in 1910, is shown dredging in 1941. She can be seen today in an interactive exhibit at the Chesapeake Bay Maritime Museum in St. Michaels, Maryland. (Courtesy of the Chesapeake Bay Maritime Museum.)

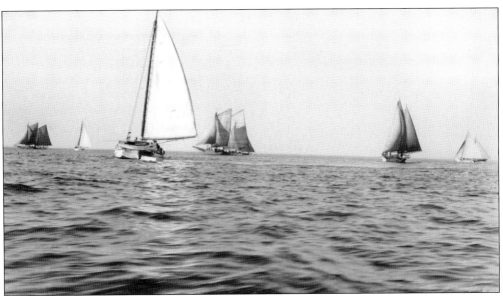

The oyster fleet is seen dredging Gales Shoals near Tolchester, Maryland, in 1941. Early settlers complained that the oyster reefs or rocks were large enough to be hazards to navigation. The best year for oyster harvesting was 1884, when over 15 million bushels were caught. The latest figures show the harvest is down to 53,000 bushels. (Courtesy of the Chesapeake Bay Maritime Museum.)

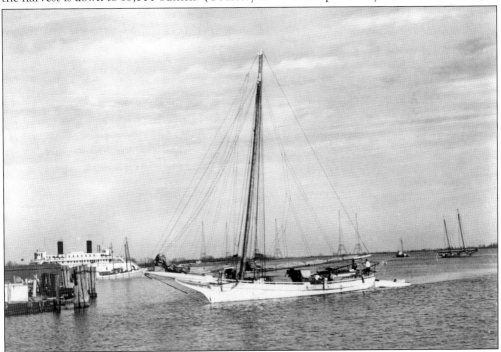

The *Lady Eleanor* is entering Annapolis in 1938 with an auto ferry in the background. Most skipjacks were built on Maryland's Eastern Shore, but the biggest markets for oysters were on the western shore where transportation was better. The B&O Railroad reached the Ohio River in 1852, opening up more markets for the Chesapeake Bay oysters. (Photograph by Leonard C. Rennie; Courtesy of the Library of Congress.)

Three skipjacks are seen reflecting in the waters of Annapolis Harbor. The season to harvest oysters is short. Skipjacks spent as much time out dredging as possible, but they had to return to port to unload their harvest, make repairs to the boat, and give the crew a chance to rest. (Courtesy of the Chesapeake Bay Maritime Museum.)

The same three skipjacks are in Annapolis, but in this view, the heights of the masts can be seen. The sail rigs are large to produce the power needed to push the skipjack through the water while dragging heavy, oyster-laden dredges behind them. A skipjack will weigh over eight tons, making them far less responsive than a modern pleasure sailboat. (Courtesy of the Chesapeake Bay Maritime Museum.)

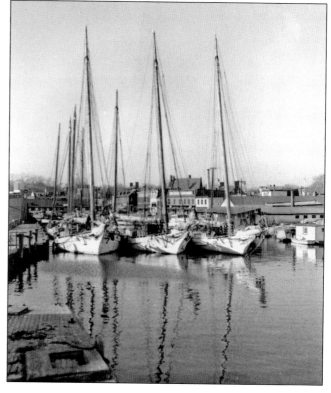

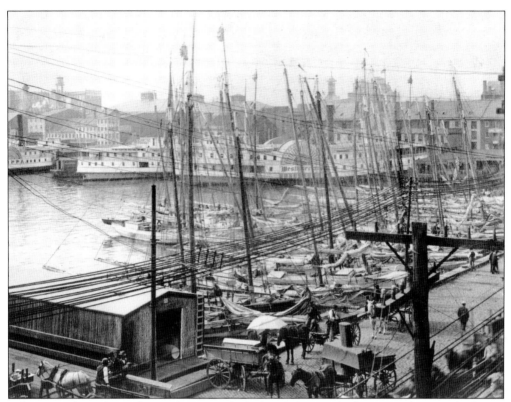

Schooners, skipjacks, and steamboats are docked in Baltimore harbor around 1900. The horse-drawn vehicles were used to move the oysters from the dock to the oyster packinghouses or to the train station. The lack of refrigeration meant the oysters had to be transported as quickly as possible. The two steamboats in the background are the *Westmoreland* and the *Joppa*. (Courtesy of the Library of Congress.)

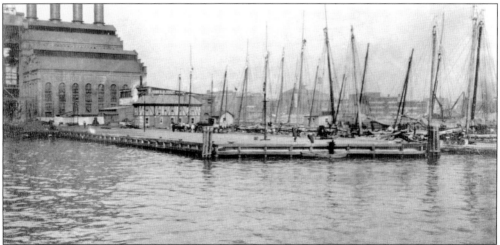

Skipjacks are lining one side of Baltimore's Pier 4 in 1912. The power plant in the background still stands today and is home to a Barnes and Noble bookstore, a Hard Rock Café, and the ESPN Zone. The National Aquarium's dolphin exhibit has been on the water end of the pier since 1991. (Courtesy of the Maryland Historical Society.)

Oysters were delivered everywhere in the Chesapeake Bay region. They are being unloaded from skipjacks and bugeyes at the Maine Street Wharf in Washington, D.C. The Old Ebbitt Grill, an institution in the capital city since 1856, serves more oysters than any other restaurant in the area. They hold the annual Oyster Riot in late November, last year shucking more than 42,000 oysters in two days. (Courtesy of the Edward C. Lawrence Collection, Calvert Marine Museum.)

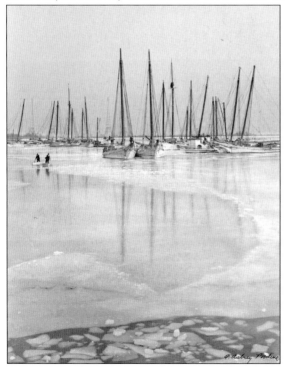

Oyster season is during the winter months. The weather is harsh, and some years are worse than others. These boats are trapped by the ice in Annapolis in 1936. That year, the Chesapeake Bay froze solid enough that you could walk across it. Valuable days were lost as the captain and crews waited for the weather to warm enough to allow dredging. (Photograph by A. Aubrey Bodine, © Jennifer Bodine; Courtesy of www.AAubreyBodine.com.)

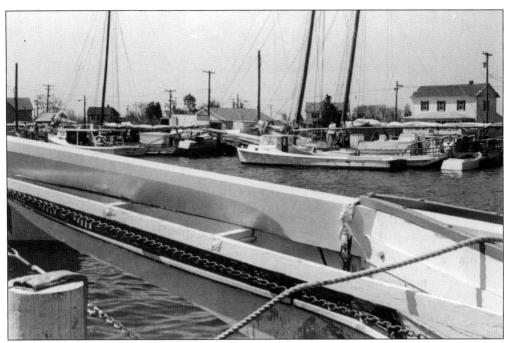

Maryland's Eastern Shore is the spiritual and, most often, geographic home of the skipjacks. These vessels are at Deal Island, the epicenter of building activity. The simple formula meant they were quick and cheap to build but were designed perfectly for their task. They were capable of pulling dredges in all types of conditions and could hold hundreds of bushels of oysters. (Courtesy of the Chesapeake Bay Maritime Museum.)

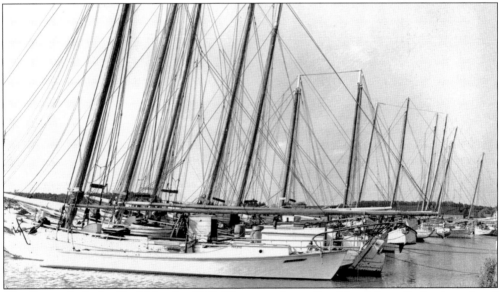

The fleet is docked at Deal Island in 1940. The oyster has suffered from the pollution introduced into the Chesapeake Bay by the human population. The Clean Water Act and other efforts have reduced industrial discharges and untreated sewage, but algae growth has increased because of fertilizer runoff from farms and lawns. The blooms cloud the water, starving it of the oxygen the oysters need to survive. (Photograph by Jack Delano; Courtesy of the Library of Congress.)

Knapp's Narrows separates Tilghman Island, near St. Michaels, from the mainland and was a popular location for skipjacks. The captains and crews of the skipjacks lived nearby on the Eastern Shore. They caught oysters in the winter, crabs and turtles in the summer, and ducks and geese in the fall. Their living came from their surroundings. (Courtesy of the Chesapeake Bay Maritime Museum.)

The push boats from the *Ralph Webster* and *Lorraine Rose* are left behind at Knapp's Narrows. Maryland law was amended in 1865 to allow dredging for oysters but only by sail-powered vessels. In 1967, the laws were again changed to allow two days a week when the engine in the push boat, located at the stern of the skipjacks, could be used. These two were eventually left to rot away in the marsh. (Courtesy of the Chesapeake Bay Maritime Museum.)

A skipjack, probably the *Seagull*, is left to rot in the waters of Deal Island. She was built in Crisfield, Maryland, in 1924 and abandoned in 1993. Most skipjacks have suffered a similar fate as the oyster industry has disappeared on the Chesapeake Bay. You can still see her dredging motor and winders. Her mast has fallen. (Courtesy of the Chesapeake Bay Maritime Museum.)

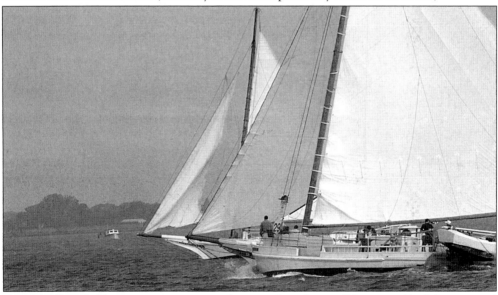

It wasn't all work. If you get two or more sailors together, there will be a race. Both bugeyes and skipjacks competed against each other. Deal Island and Cambridge still have annual skipjack races every fall, and many of the surviving skipjacks attend and race. (Photograph by Lowndes Johnson; Courtesy of Amy Kehring.)

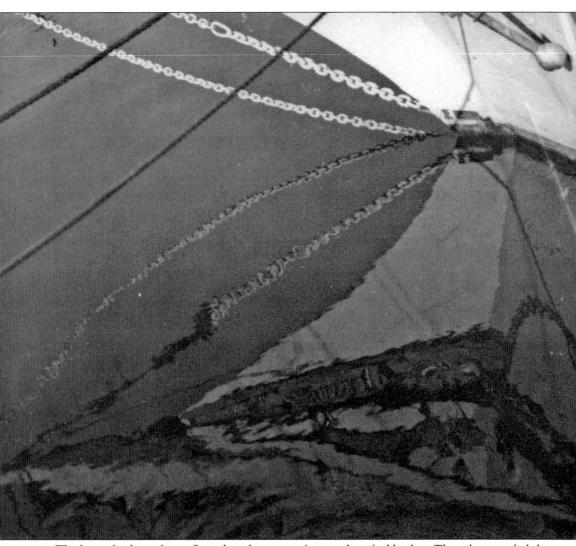

The bow of a skipjack is reflected in the water of an unidentified harbor. These boats sailed the Chesapeake Bay for over 100 years until economics and time took their toll. The Chesapeake Bay Maritime Museum lists 36 survivors out of 1,000 built, but keeping them floating takes time and money. (Courtesy of the Chesapeake Bay Maritime Museum.)

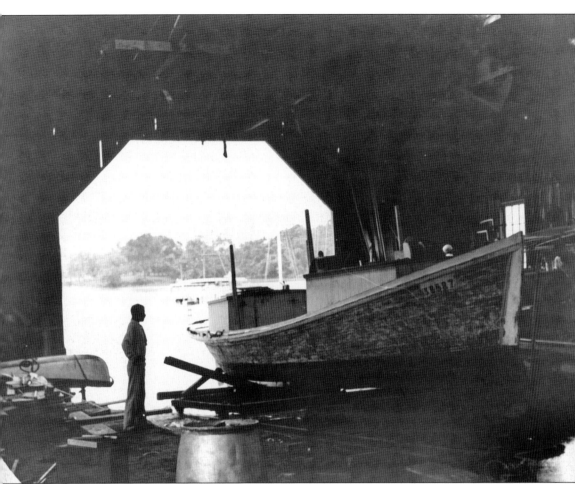

A boat is being worked on in 1937 in the shed at Hartge's Boatyard in Galesville, Maryland. Hartge's has been in business since 1865 and was one of the few yards on the western shore active during the boom years of the skipjack. The yard is now operated by the fourth generation and still has expertise in wooden boats. They have both a 40-ton and a 70-ton marine railway, making their yard one of the few places left capable of lifting a skipjack out of the water for repairs. Many surviving boats take advantage of their equipment, their expertise, and the quality of their work. (Photograph by Leonard C. Rennie; Courtesy of the Library of Congress.)

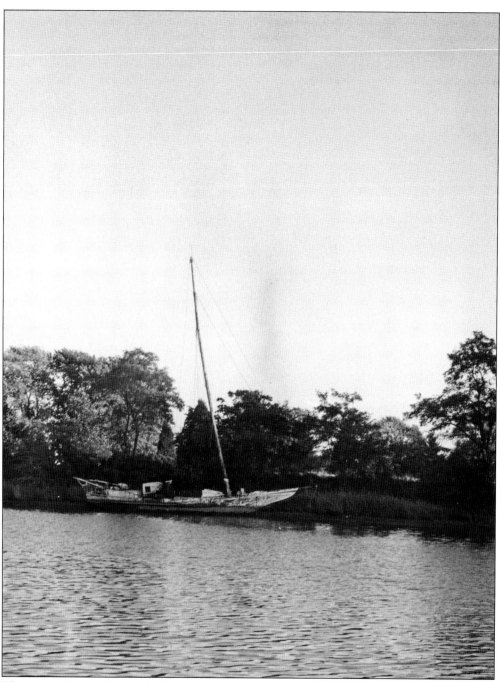

The vast majority of skipjacks did not end up in the boatyard at Hartge's or in the restoration program at the Chesapeake Bay Maritime Museum. They were pulled into the marches and weeds along the Eastern Shore and left to disappear with the effects of time. It was often less expensive to replace an older boat or, as the oyster harvest became less of an economic factor, to leave the industry behind. The rise of the blue crab as an important crop is largely due to the decline of the oyster, and skipjacks were not designed to raise crab pots off the bottom of the bay. (Courtesy of the Chesapeake Bay Maritime Museum.)

Two

THE DETAILS OF
A SKIPJACK

This bird's-eye view of the *E. C. Collier* out of the water for repairs shows the overall size and shape of a skipjack. They are wide in the beam for stability under sail and for cargo capacity. This skipjack was built at Deal Island, Maryland, in 1910 and is now at the Chesapeake Maritime Museum in St. Michaels. (Courtesy of the Library of Congress.)

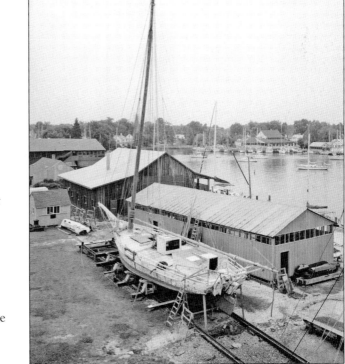

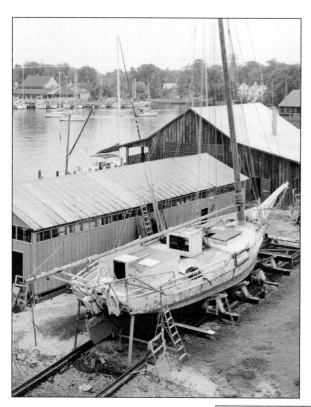

The masts on skipjacks are stepped, or mounted, well toward the bow, which allows the large mainsails needed to generate power. The masts are also bent, or raked, severely back toward the stern. This causes the boat to want to turn its bow into the wind, a condition called boat weather helm. The right amount of weather helm gives the captain at the wheel more feel when the skipjack is under sail, but too much weather helm and the boat becomes hard to sail. (Courtesy of the Library of Congress.)

The sharp bow of the *E. C. Collier* is designed to cut through the choppy winter waters of the Chesapeake Bay. The average depth of the Chesapeake Bay is around 20 feet, and a six-foot person can walk 700,000 acres of it and their head won't go under water. A skipjack with a shallow draft and flat bottom was built with the local waters in mind. The schooners that out-of-state competitors favored were expensive to build and limited in where they could go because of their deep keels. (Courtesy of the Library of Congress.)

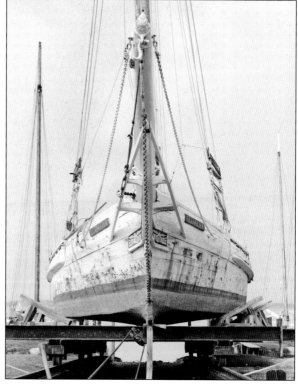

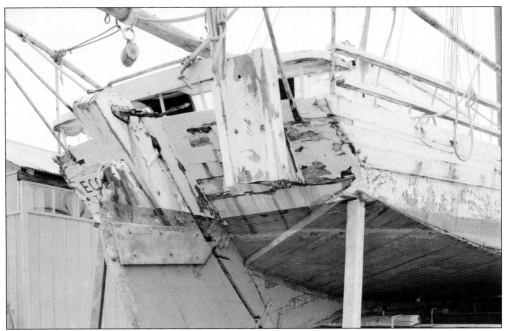

The boards that form the sides of a skipjack run bow to stern, but the bottom planks are placed at right angles to the centerline of the boat and hammered into place against the chine, or centerline of the skipjack. The outside, raw edges are trimmed flush with the sideboards. This removed the need for expensive and time-consuming steam bending. (Courtesy of the Library of Congress.)

The bow of the *E. C. Collier* with her cut, water-styled stem takes waves better than blunter styles. The raw edges of the bottom planking are protected by tar and copper sheathing, but water still wicks its way into the ends of the boards. The planking needs to be replaced frequently, and the cost has become prohibitive as the oyster harvests decline. (Courtesy of the Library of Congress.)

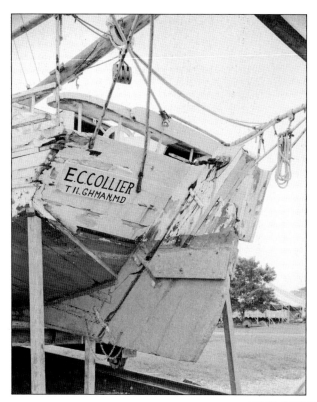

A closer view shows the barn door–styled rudder in detail. Modern boat designers use computer models to size the rudder on a sailboat. The skipjack builders knew by feel that a large rudder made it sail better. If the rudder was not oversized, it would be almost impossible to steer a skipjack because of their weight and their shallow keels. (Courtesy of the Library of Congress.)

The bow sprit moves the front edge of the foresail out over the water. A large jib, set forward, helps push the heavy skipjack through the turns. The bow sprit was normally the same length as the boat's width. Moving the jib forward also cleared more deck space for hauling oysters. (Courtesy of the Library of Congress.)

The bow sprit and the base of the mast as it passes through the deck are shown. The post that the ropes wrap around is a capstan, or Samson post. The dock and anchor lines are secured to it, and it forms part of the support for the bow sprit. The starboard shrouds that help hold up the mast are seen along the right edge of the photograph. (Courtesy of the Library of Congress.)

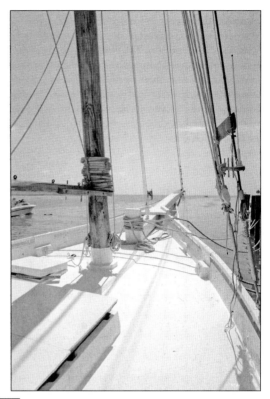

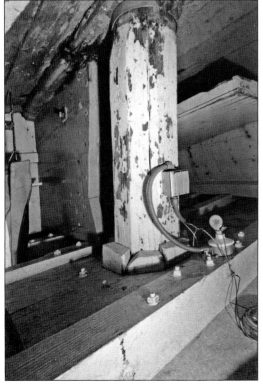

The mast is heavy and has to be supported under the deck by a mast foot and deck beams. They act like a header and window cripples in house construction. They help carry the load as well as providing additional support when the pressure of the wind is against the sail, straining the mast. (Courtesy of the Library of Congress.)

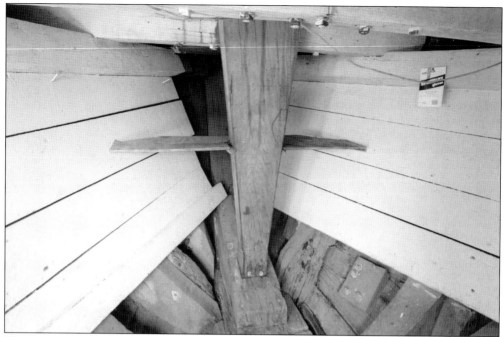

The Samson post, or capstan, is also supported beneath the deck. The details of the construction in the bow of the skipjack *Kathryn* can be seen here. If the capstan is not properly supported and secured, it could pull out when the anchor or dock lines are strained by the wind and current. (Courtesy of the Library of Congress.)

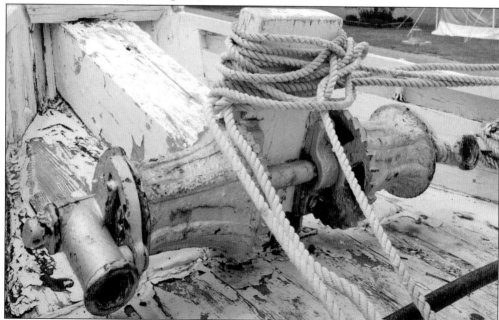

The two metal drums on each side of the capstan are windlasses. The windlass will rotate, providing the crew mechanical assistance when raising the heavy anchors. A handle is inserted, and when it is pumped up and down, a ratchet is activated, turning the windlass drums. Metal parts had to be ordered from Baltimore or Philadelphia. (Courtesy of the Library of Congress.)

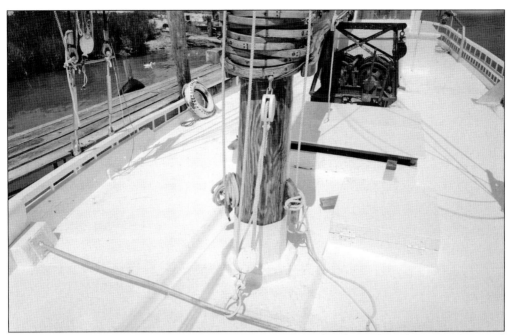

The various lines needed to raise and control the sails are coiled alongside of the mast. The metal rod running across the boat in front of the mast is called the jib traveler. It allows the forward sail to move freely from side to side as the skipjack turned and maneuvered under sail. (Courtesy of the Library of Congress.)

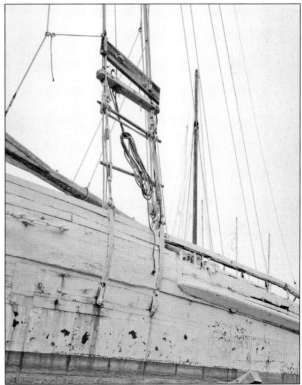

The shrouds, hemp, and metal lines installed on each side of the boat are fastened to the mast and bolted into the side of the boat. The pressure of the wind against the sail will break the shrouds if they aren't properly engineered for the load. The horizontal boards are used to fasten various lines used in sailing the boat. The name shroud comes from the days of the square-rigged warships. There were so many lines holding up the mast that it was shrouded from view. (Courtesy of the Library of Congress.)

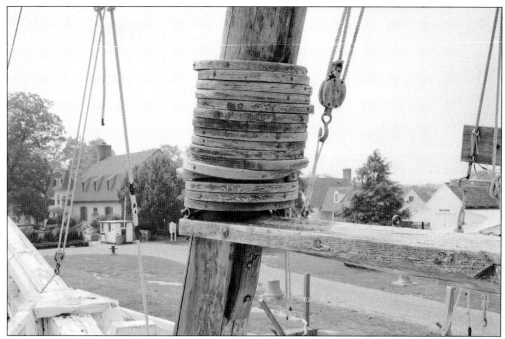

This view of the mast hoops shows the jaws, which attach the boom to the mast. The mainsail is laced to the wooden mast hoops. The weathering can be seen in the mast's checks and cracks. Masts were expensive to replace because of the difficulty finding a tree tall and straight enough to create a new one. A skipjack would have several masts during her lifetime. (Courtesy of the Library of Congress.)

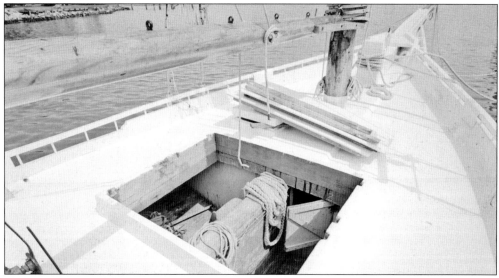

This view is toward the bow with the forward cabin hatch removed. The top of the centerboard trunk can be seen. Skipjacks have a flat, V-shaped hull that can work in shallow water, but they also have a centerboard that can be lowered in deeper water. This provides more upright stability but also allows the skipjack to sail with her bow closer to the wind, giving the captain more options while dredging. The maximum length of the centerboard is one-third the length of the deck, with 10 to 12 feet being the average size. (Courtesy of the Library of Congress.)

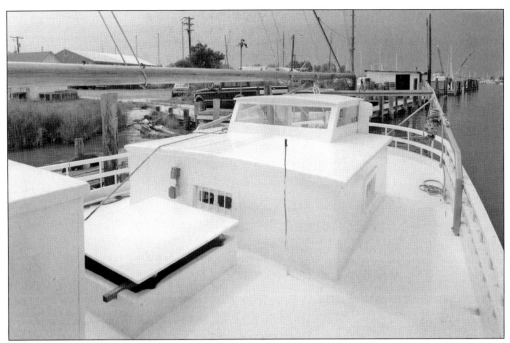

A view toward the stern shows the mid-house hatch covering a hold below decks and the actual cabin where the crew could eat, rest, and get out of the weather. The lines looped around the boom are called lazy jacks. These prevent the sail from falling across the deck when the crew drops the mainsail. (Courtesy of the Library of Congress.)

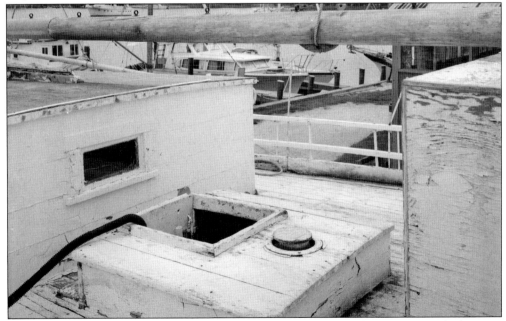

The mid-deck hold is used to store equipment and other gear. A skipjack often mounts the batteries needed to start the push boat engine and run the various required lights in this hold. Oysters are piled on deck, not in the holds. The hatch cover is usually propped slightly open to allow air to flow inside the boat, helping to prevent wood rot. (Courtesy of the Library of Congress.)

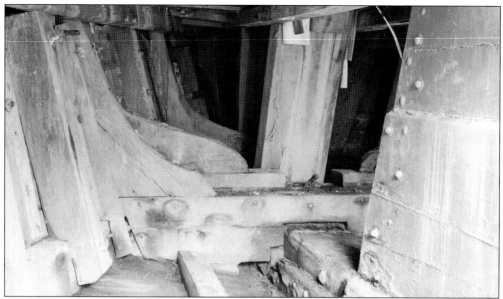

The forward hold of a skipjack is where the crew would load watermelons or other cargo they would carry during the summer. The forward post supports the mast, and above is a deck beam. The trunk for the centerboard is to the right. Everything is made of wood, and moisture is the mortal enemy of wood. Rot will set in if the boat leaks and most do. Insects will be attracted to the damp wood. Maintenance is constant on a wooden boat; carrying cargo other than oysters helps pay for it. (Courtesy of the Library of Congress.)

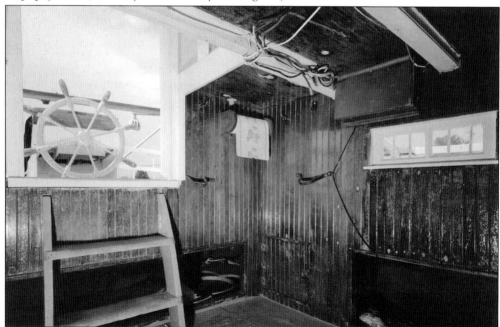

The inside view of the *Kathryn*'s cabin shows the ladder for climbing out onto the deck. The wheel can be seen outside. The walls were made of bead board. There was little effort taken to make the cabin comfortable. It was more for storage than a living area. Skipjacks were made for work, not pleasure sailing. (Courtesy of the Library of Congress.)

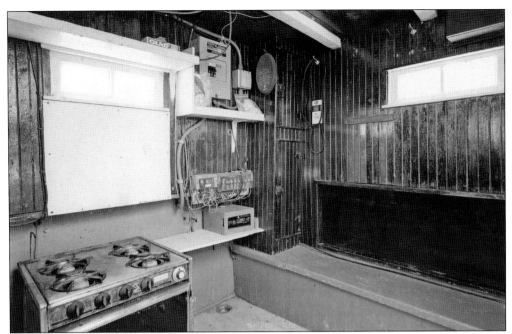

The stove and bunk inside the cabin of a skipjack was home for a skipjack crew between November and April. The stoves went from wood fired, to coal, oil, maybe diesel fuel, alcohol, to propane and now compressed natural gas. The electrical panel to the right has been added. (Courtesy of the Library of Congress.)

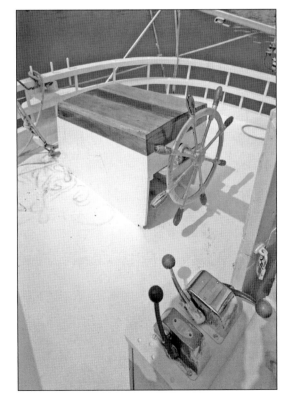

Here is the helm with the wheel attached to the box containing the steering gears. In the foreground are the controls for the engine installed in the push boat or yawl. The rail at the stern, or rear, has three pins through it, one with a line wrapped around it. These are belaying pins used to secure lines around the boat. (Courtesy of the Library of Congress.)

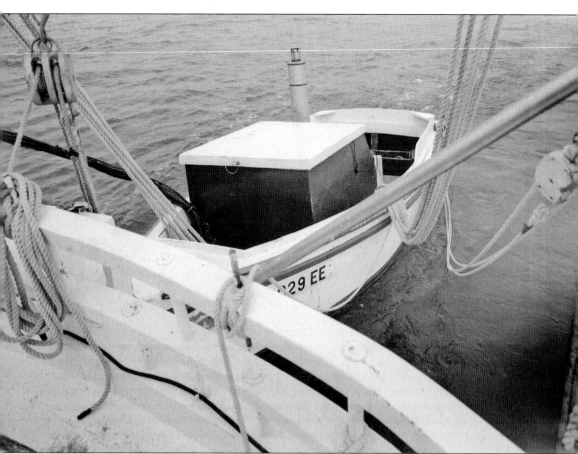

This is the yawl or push boat at the stern of the *Kathryn*. The wooden box in the push boat contains the engine. Originally a crew member would have to climb into the push boat to run the engine. The controls have been moved within easy reach of the helm on most surviving skipjacks. The wheel is turned to change the rudder angle. A modern sailboat turns fast with only a slight movement of the wheel. The wheel of a skipjack has to go from lock to lock to turn the boat. It takes time to complete a turn, so a good captain plans ahead, building enough boat speed to carry the boat around. (Courtesy of the Library of Congress.)

The *E. C. Collier* is back in a slip after repairs and restoration. You can visit the *E. C. Collier* at the Chesapeake Bay Maritime Museum in St. Michaels. Two other skipjacks can be seen beyond the *E. C. Collier*. They have their mainsails installed on the boom. The building on the left side is the Hooper Island Lighthouse on the museum property. The cost of restoring a skipjack is far more than their original cost. The *Martha Lewis* spent over $150,000 replacing boards on the right side of the hull and bottom in 2006. A total rebuild might be close to a half a million dollars. A skipjack could be bought new in 1900 for less than $2,500. (Courtesy of the Library of Congress.)

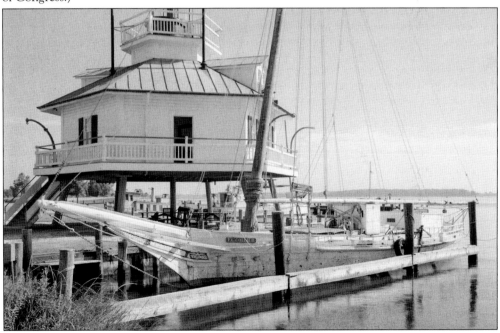

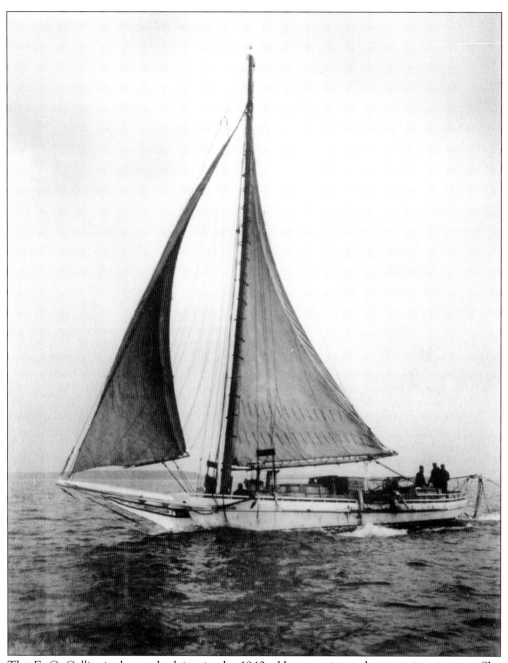

The *E. C. Collier* is shown dredging in the 1940s. Her crew is on the stern in rain gear. She survives because of the efforts of a small group of people who felt that an important part of Maryland history was passing away. She is part of an exhibit about oysters and oyster dredging at the Chesapeake Bay Maritime Museum. The museum has an extensive skipjack restoration program in place and has done work on about a dozen of the surviving skipjacks, including the *E. C. Collier*, the *City of Crisfield*, the *Lady Katie*, the *Rosie Parks*, and the *Somerset*. (Courtesy of the Chesapeake Bay Maritime Museum.)

Three

SKIPJACKS ON THE WATER

The skipjacks wait in the harbor. This photograph dates from the 1970s, the last decade a large number of skipjacks actively worked the waters of the Chesapeake Bay. The effort to improve the economics of the skipjacks by introducing power days slowed their disappearance but was not successful in saving all of them. (Courtesy of the Chesapeake Bay Maritime Museum.)

The skipjacks *Dorothy* and the *Ethelyn Dryden* are tied to the dock. These are two of many examples where a skipjack was built, dredged, retired, and disappeared without a trace. This photograph dates from the 1930s, but the location is unknown. The other factor in determining the fate of skipjacks is that a boat would range far from its original home ground in search of good, productive oyster beds and could change owners several times. (Photograph by Arthur A. Moorshead; Courtesy of the M. V. Brewington Collection, Calvert Marine Museum.)

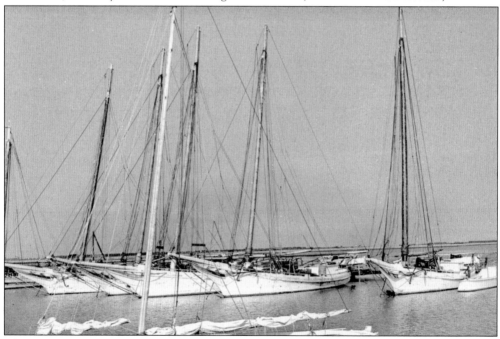

The workboats gather at Deal Island in 1940. There is the skipjack *Esther W.*, the *Florence Louise*, the *Amy Mister*, and the *Eben* along with the bateau, *Dayton*, in the foreground, and a buyboat to the right. Maryland and Virginia recognized as early as the 1860s that there was a danger of over-harvesting. (Photograph by Jack Delano; Courtesy of the Library of Congress.)

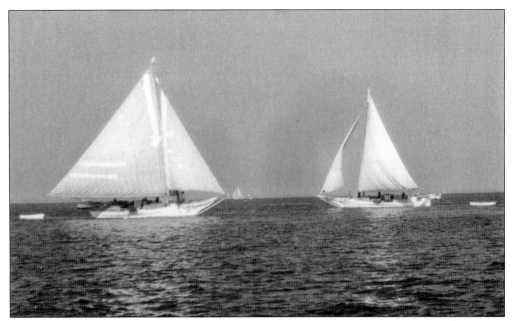

The names of these two skipjacks under sail are lost. The vessels appear awkward and ungainly sitting still, but the functional elegance of their simple design can be seen when they are under way. The design is a masterpiece of simplicity that is cost effective and functional. (Courtesy of the Chesapeake Bay Maritime Museum.)

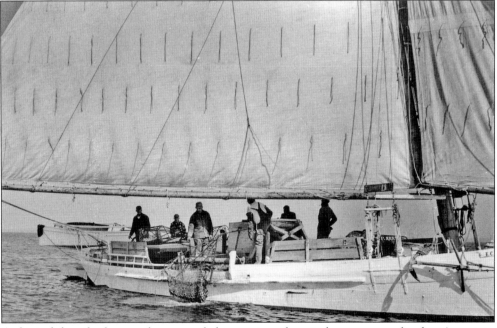

A skipjack has the large sail area needed to capture the wind even on a calm day. A captain and crew would never know what the weather held for them as they went out to dredge. Winter days on the Chesapeake Bay can be mild enough to work in shirt-sleeves or fierce enough that ice forms on the boat's rigging. The sails had to ready for use in all conditions. (Courtesy of the Chesapeake Bay Maritime Museum.)

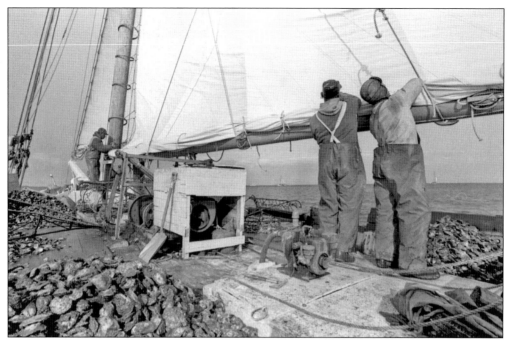

The crew is reefing the mainsail. The large sail area means when the speed of the wind increases, the sail has to be reduced, a process called reefing the sails. The boat may actually sail faster with less sail in heavy breezes because the captain has more control at the helm. (Courtesy of the Chesapeake Bay Maritime Museum.)

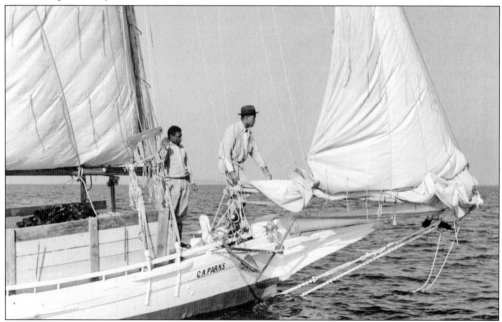

The captain determines how the sails should be set to balance the boat in higher winds. Here the crew is reefing, or reducing, the size of the jib on the C. A. Parks. The jib is smaller and is usually reefed after the mainsail. It's all about maintaining enough power to pull the dredges while being able to sail without fighting the boat. (Courtesy of the Chesapeake Bay Maritime Museum.)

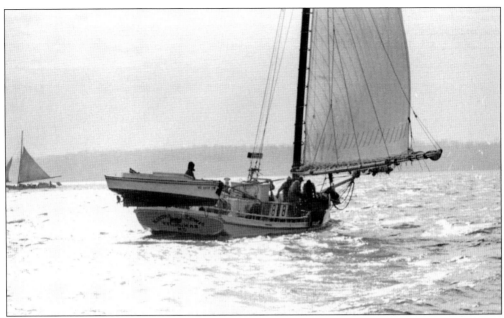

The *Martha Lewis* is moving along under full sails. The number eight, her oyster license, has to be large enough the marine police can see it from a distance. Regulating oyster boats was one of the first steps in controlling the harvests. The first license law went into effect in 1865. The Department of Natural Resource Police in Maryland and the Virginia Marine Police were originally founded to regulate the oyster catch. (Courtesy of the Chesapeake Bay Maritime Museum.)

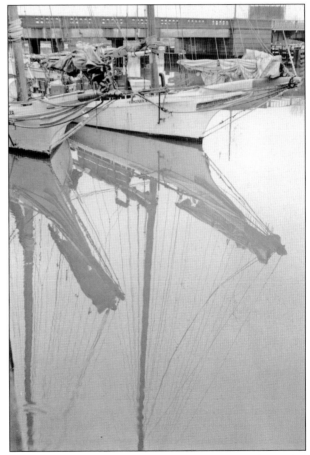

The crews of the *Lucy Tyler* and the *Virginia W.* have tied the mainsails to the boom using sails ties, a step called flaking the sails. This keeps the mainsail neat and out of the way. The jib is dropped onto the bow sprit and is held in place by lazy jacks, lines that loop around the bow sprit and go up to the mast, creating a cradle for the sail. These boats are docked in Cambridge. (Courtesy of the Chesapeake Bay Maritime Museum.)

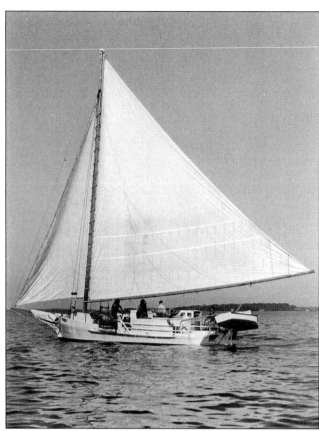

The *Hilda Willing* is dredging in the Choptank River. She was built in 1905, is now a National Historic Landmark, and dredged as recently as the 2005–2006 season. Dredging is done during daylight hours, but the short winter days means the boats often returned with their harvest after dark. The hours for a crew were long, and they usually worked seven days a week. Today** dredging can only be done on weekdays. (Courtesy of the Chesapeake Bay Maritime Museum.)

The *Minnie T. Phillips* is at a snow-covered dock in Tolchester, Maryland, in 1941. The family that owned her took a number of photographs that year of her and other skipjacks working Gales Lump or Shoals, an oyster reef off of Tolchester. The details of her construction and her fate are unknown. (Courtesy of the Chesapeake Bay Maritime Museum.)

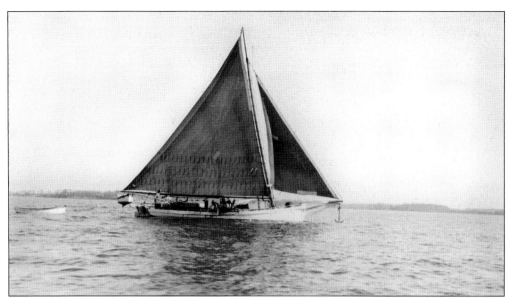

The G. W. Collier is working the oyster beds near Tolchester in 1941. She was built in 1900 on Deal Island by G. W. Horseman and is now being rebuilt as the skipjack *Norfolk* by the East Harbor Boat Works, a nonprofit boatbuilding project that is part of the Cape Charles Renewal Project in Virginia. (Courtesy of the Chesapeake Bay Maritime Museum.)

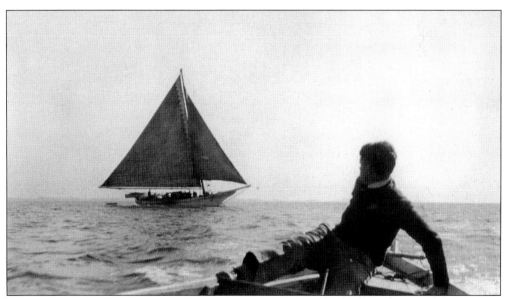

The oyster reef in Kent County, Maryland, was one of the most productive areas in the upper Chesapeake Bay, despite being only several miles south of the oyster line, the imaginary line where the Chesapeake Bay moves from being saltwater to freshwater. The skipjack *Denne Foster* is working over the reef, which is still shown on a navigation chart, but is closed to dredging. (Courtesy of the Chesapeake Bay Maritime Museum.)

An unidentified skipjack is shown in a photograph that dates from the 1930s. It may be the *Lady Eleanor* returning to Annapolis in 1937. She was built in 1915 by William A. Noble in Gennguakin, Maryland, near Oriole on Deal Island. Noble built several skipjacks, some of which survive, but the *Lady Eleanor* is lost to history. (Courtesy of the Chesapeake Bay Maritime Museum.)

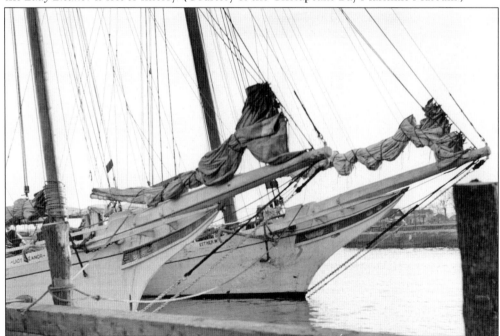

The *Lady Eleanor* and the *Esther W.* are tied up to the dock in Annapolis. Esther was used as part of the name on a number of skipjacks. There was also the *Esther F.*, the *Esther D.*, and the *Esther G.* Eleanor and Esther could have been sisters, both married to skipjack captains who honored their wives. (Courtesy of the Chesapeake Bay Maritime Museum.)

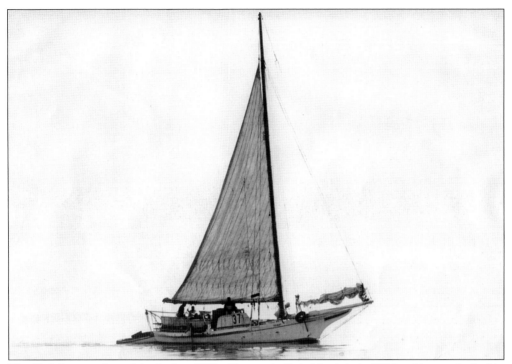

The *Ida May* is under sail in the late 1930s. She was built in Virginia in 1906 and is now docked in Chance, Maryland. She raced as recently as 2005 but is now undergoing restoration. These boats were never expected to last 100 years. The construction methods used were quick and inexpensive, not designed for longevity. (Courtesy of the Chesapeake Bay Maritime Museum.)

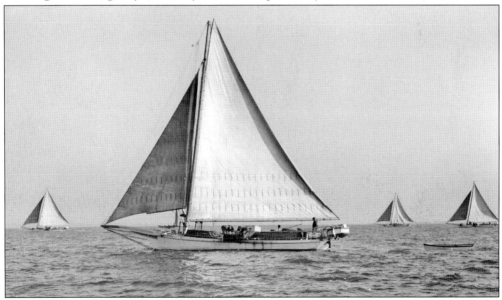

A group of skipjacks, with the *Joy Parks* in the foreground, is dredging. She was built in 1936 at Parksley, Virginia, and was moved to Washington, D.C., to be part of a special exhibit at the Smithsonian Museum in 2004. She is currently at the Piney Point Lighthouse Museum and Park on the Potomac River. (Courtesy of the Chesapeake Bay Maritime Museum.)

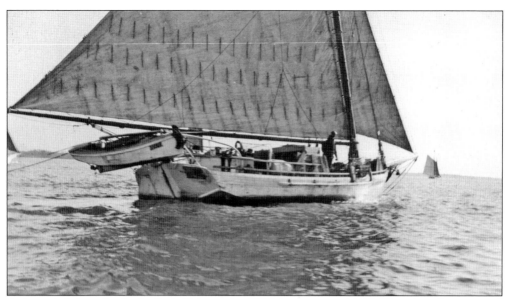

A skipjack, believed to be the *Lady Helen*, sails off Tolchester around 1937. There have been several boats with the name *Lady Helen*, including one built in 1987. The *Lady Helen* of 1937 was 42 feet long and just over 14 feet at the beam. (Courtesy of the Chesapeake Bay Maritime Museum.)

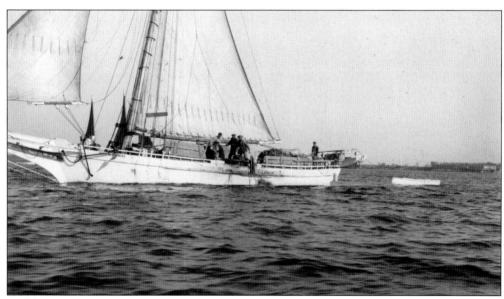

Welsh names such as Thomas dominate Maryland's Eastern Shore. Joshua Thomas was known as the "Parson of the Islands" and was partially responsible for the growth of the Methodist church in the communities along the Eastern Shore. Early in his life, he was an apprentice to Capt. David Tyler, who taught the future minister boatbuilding skills. This is the skipjack *Ruth Thomas* under sail, which could be named after one of the parson's many relatives. (Courtesy of the Chesapeake Bay Maritime Museum.)

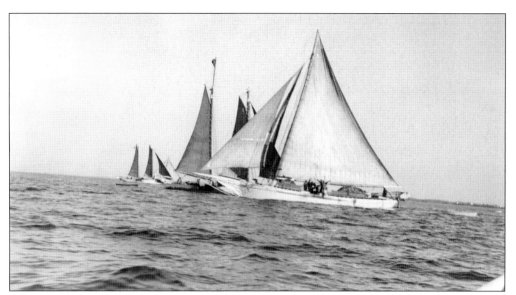

There is a long-standing tradition of workboat races on the Eastern Shore. The first recorded race was from Deal Island to Baltimore in 1871. They became more formal affairs beginning in 1921, but as the number of skipjacks and bugeyes dwindled, the races became less frequent. This photograph dates from the late 1930s and shows the *Florence Lowe* under sail near Kent County. (Courtesy of the Chesapeake Bay Maritime Museum.)

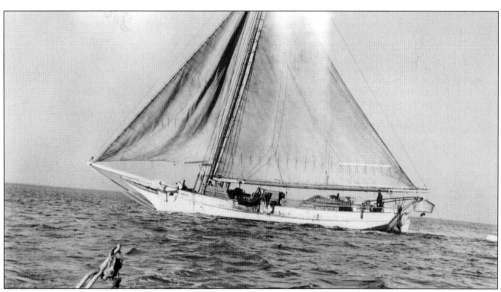

The *Robert L. Webster*, dredging near Rock Hall in the late 1930s, was built in 1915 at Oriole, Maryland, and was broken apart in 1981. She was one of the larger skipjacks, coming at slightly over 60 feet. The tradition of formal workboat races was revived in early September 1960, when 14 vessels crossed the starting line on a windless day in Tangier Sound off of Deal Island. The *Robert L. Webster* with Capt. Eldon Willing at the helm was one of them. (Courtesy of the Chesapeake Bay Maritime Museum.)

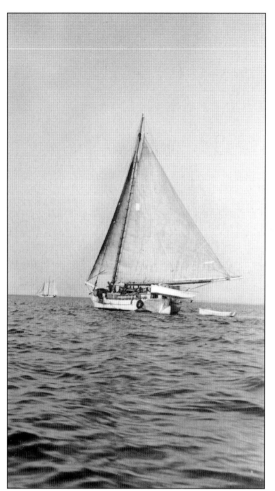

The skipjack *Maime Mister* was built near Champ, Maryland, around 1910. At 56 feet on deck, she is another of the large skipjacks. She was used for charters and sail training in New York Harbor for several years in the early 1980s and was hauled out for work in 2005. The boat in the distance is a three-sail bateau. She carries two masts instead of the usual one. (Courtesy of the Chesapeake Bay Maritime Museum.)

The skipjack *Annie Lee* is off of Tolchester in 1939. Many skipjacks had Annie or Lee in their names. The Eastern Shore of Maryland where skipjacks were born is still primarily rural country, with only eight percent of Maryland's total population on a third of the state's total land. There is a long tradition of farming and fishing. Because it is separated from the rest of Maryland by the Chesapeake Bay, it has its own culture. (Courtesy of the Chesapeake Bay Maritime Museum.)

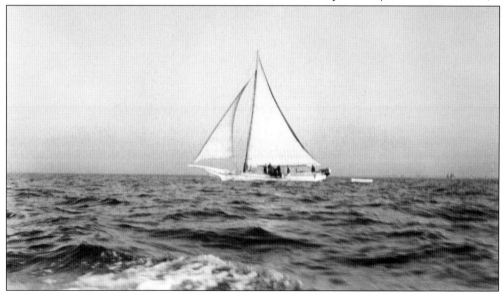

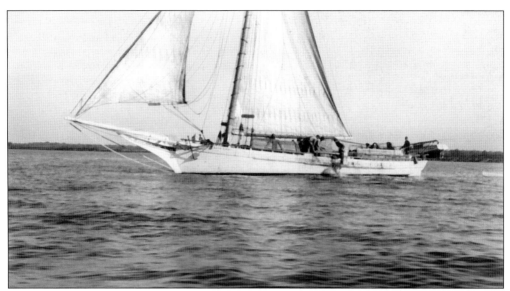

The *Annie Lee* is shown from another angle in a photograph taken the same day. James Michener's novel *Chesapeake* was published in 1978 and brought skipjacks to the attention of a wider audience, many of whom were surprised to find that the boats had almost completely disappeared. The fictional Devon Island was supposed to be at the mouth of the Choptank River and near where many of the skipjacks were built and worked. (Courtesy of the Chesapeake Bay Maritime Museum.)

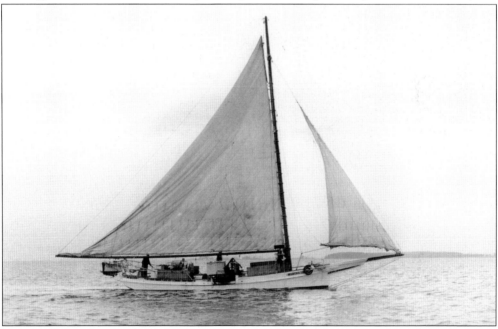

The *Martha Lewis*, named after her first captain's mother, is still an active skipjack. She was built in 1955, along with the *Lady Katie* and the *Rosie Parks*, in Wingate, Maryland. She was restored in Havre de Grace, Maryland, in 1993 and still does oyster trips every November and December under license number 8. Bronza Parks built her and her sister vessels as working skipjacks, a tradition she continues by going out for oysters every year. (Courtesy of the Chesapeake Bay Maritime Museum.)

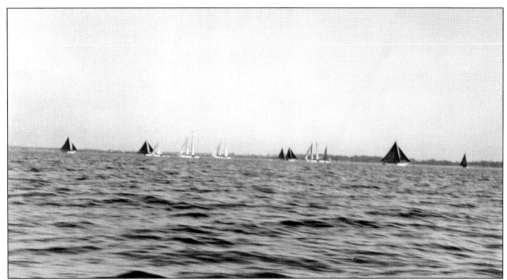

The skipjack fleet is under sail in the late 1930s. Tolchester is near the prime oyster reefs of the mid–Chesapeake Bay. Skipjacks could reach Man o' War Shoals, Gale's Lump, the Six Foot Knoll, the Seven Foot Knoll, and the Nine Foot Knoll. The seas can get rough in this area during the winter. The Seven Knoll Lighthouse, now in Baltimore's Inner Harbor, recorded some of the highest waves ever seen on the Chesapeake. (Courtesy of the Chesapeake Bay Maritime Museum.)

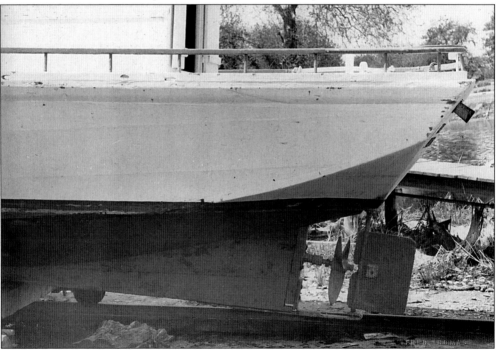

The stern of the skipjack *Barbara Batchelder* is shown sitting on an unidentified marine railway. There are no records on this vessel, but she is featured in a painting by the Eastern Shore marine artist Christine Diehlmann. The builders and captains were not romantic about their skipjacks, but they held a good boat in high regard because it provided a better platform to make a living. (Courtesy of the Chesapeake Bay Maritime Museum.)

An unidentified skipjack sails across the Chesapeake Bay. There were many photographs taken, but often no one bothered to note what boat it was. The early skipjack crews would be perplexed by the affection we show these vessels. It was hard work, and while they would probably be disappointed in the fate of the oyster, they would be looking at easier methods of harvesting them. (Courtesy of the Chesapeake Bay Maritime Museum.)

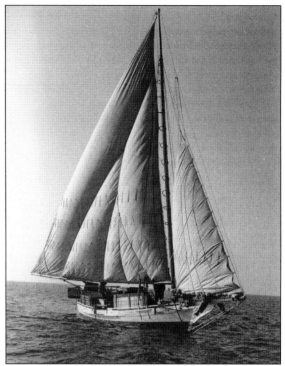

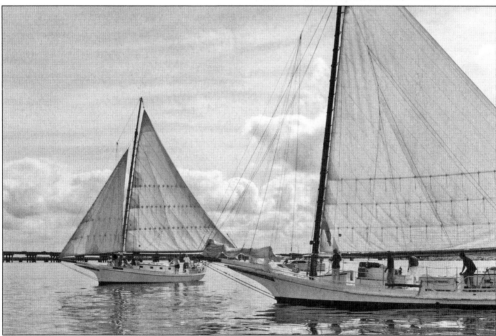

These two are navigating one of the shallow and narrow channels that are characteristic of the Eastern Shore. The skipjack captains know the waters and can safely take a boat where others would never venture. The shallow drafts of the skipjacks helped, but it was more knowledge than design. Prior to the widespread use of the push boats, a skipjack could only sail. Bringing a skipjack into port required a skilled captain and crew. (Courtesy of Amy Kehring.)

These skipjacks are tied to the dock in Cambridge. Cambridge was one of the centers for skipjacks over the years because of its location near the prime oyster beds. The boats were built there, docked there, delivered their catch there, and abandoned there. Skipjacks built at other locations would spend the season near Cambridge, selling their catch to the local packinghouses. It is still home to the *Nathan of Dorchester*. (Courtesy of Amy Kehring.)

The *Rebecca T. Ruark* is the oldest surviving skipjack, built in 1886 by Moses Geoghegan at Taylor's Island, Maryland. She is 53 feet long, 17 feet wide, has a draft of four feet, six inches with the center board up and slightly over nine feet when it's lowered. She is both a National Historic Landmark and the oldest vessel certified by the U.S. Coast Guard to carry passengers. She participated in the skipjack races in 2007. (Courtesy of Amy Kehring.)

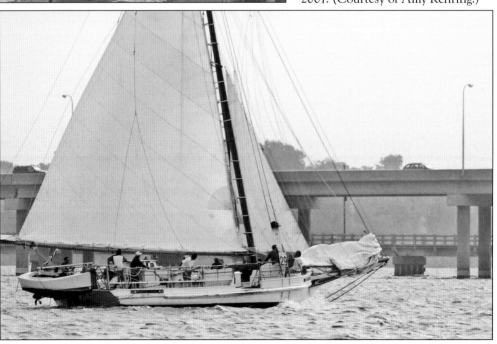

Four

THE BUSINESS OF
DREDGING

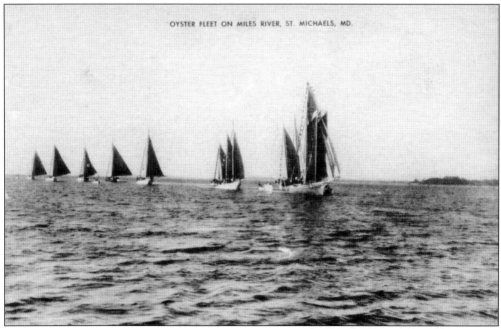

The oyster fleet leaves St. Michaels, Maryland, in the 1930s. This is a fraction of the skipjacks that would dredge during the prime years of oyster harvesting. They would head out from Cambridge, Crisfield, Tilghman Island, Deal Island, and ports along Maryland's western shore. There were over 200 possible reefs to work over in those days. (Courtesy of the Chesapeake Bay Maritime Museum.)

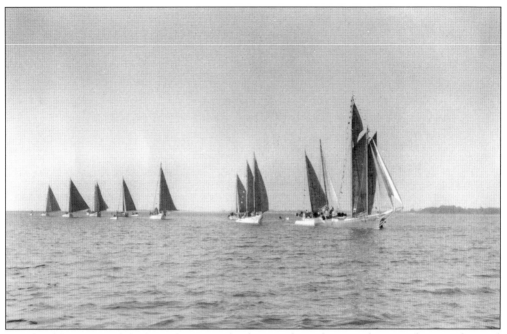

Maryland law required dredging for oysters be done under sail power alone until 1967. The yawl or push boat, where the engine is located, can now be used two days a week. These skipjacks are setting out in a time when only the sails could be used, but oysters were far more plentiful in 1930. (Courtesy of the Chesapeake Bay Maritime Museum.)

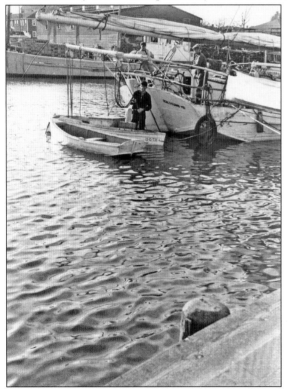

The push boats and crew of the *Esther W.* docked in Annapolis in 1937. A close look at the transom shows her home port of Deal Island, which is across the Chesapeake Bay and farther south. The push boat is ready to be raised. The other boat at the stern is a small skiff the crew used to get to and from shore. The oyster police look for the license on the shrouds and to see if the push boat is out of the water. (Courtesy of the Chesapeake Bay Maritime Museum.)

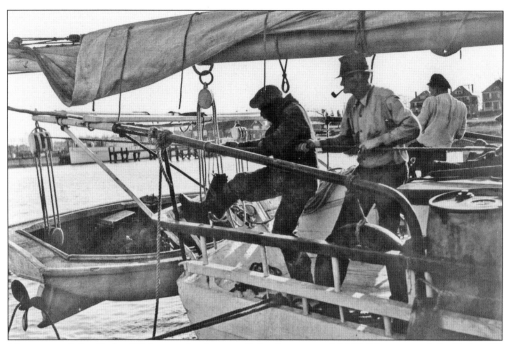

The stern of the *Esther W.* is seen in Annapolis harbor around 1937. The crew of the *Esther W.* is hoisting the yawl onto the davits at the stern of the vessel. Many skipjack captains fought the 1967 change in the law regarding dredging under power on Monday and Tuesdays. It changed the economics of oyster harvesting enough that it may have saved the remaining boats from extinction. (Courtesy of the Library of Congress.)

The dredge baskets line the docks of Baltimore harbor in 1905 waiting for the season to begin. The off season was the time to repair equipment. Dredge baskets were just one item. Sails had to be fixed, or new ones made, rotted boards replaced, and new lines installed to get the boat in condition for dredging. These are probably new baskets, but captains were tight with their money. A new one would be a last resort. (Courtesy of the Library of Congress.)

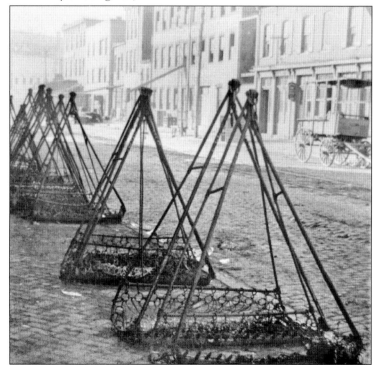

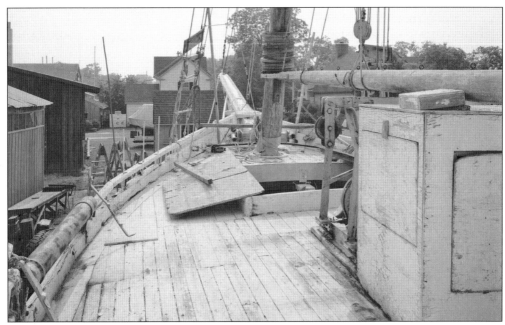

A wooden housing covers the engine used to run the dredges. The muffler could be removed when the engine was not in use and then refitted during dredging operations. A hole in the top of the box allows the exhaust fumes to escape. The box deadens the loud noise of the engine running, but any conversation must be shouted. (Courtesy of the Library of Congress.)

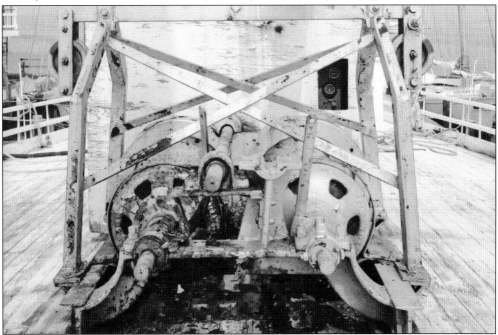

The dredges on early skipjacks had to be raised by hand. Small block car engines were added later with powered drums, called winders. The steel cables connect the dredge basket to the winders. If the engine fails, a new one is found at a junkyard, but breaking a cable or losing a dredge means the skipjack is out of business. (Courtesy of the Library of Congress.)

The winder machinery is connected to the dredge motor. The winders are controlled by handles and foot pedals that either release the dredge cable, lowering the basket, or engage the winders for retrieval. Short lines, called beckets, are tied onto the dredge cable to stop the cable when the proper length is released. (Courtesy of the Library of Congress.)

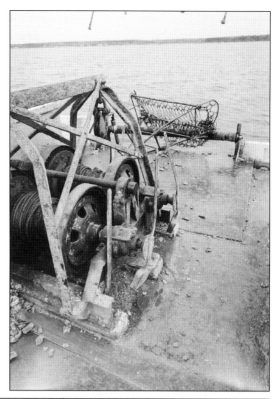

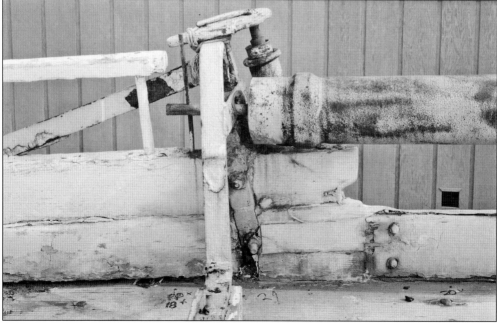

The dredge cable runs over a horizontal roller mounted firmly about mid-ship on the gunnels of the skipjack. This allows the cable to move freely as it is released or retrieved, and it protects the sides of the skipjack from the chafe of the steel cable. The builders knew where the weak points would be and made sure they were covered. (Courtesy of the Library of Congress.)

A close up of the vertical roller is pictured here. The dredge cable is swept back in the current created by the forward motion of the boat. The vertical roller comes into play, keeping the cable in proper alignment and preventing it from sawing through the side of the boat. The crew members have to make sure their legs are out of the way of the cable as it is released. (Courtesy of the Library of Congress.)

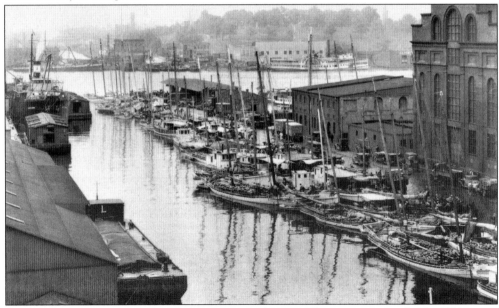

The fleet lines the long dock, known as Pier 4, in Baltimore. They're are waiting for the 1931 season to begin. The power plant is the building in the right of the frame; the dolphin exhibit of the National Aquarium is now on the end of the pier. Federal Hill, now an exclusive neighborhood of revitalized Baltimore, is seen across the water. (Courtesy of the Maryland Historical Society.)

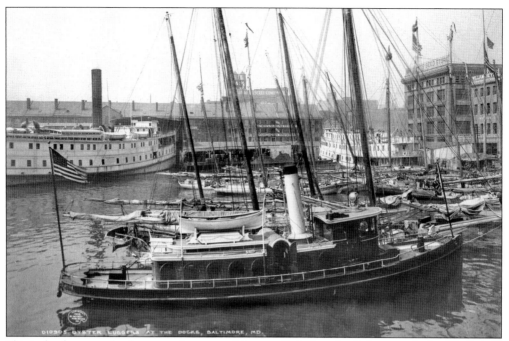

Skipjacks, bugeyes, buyboats, and a steamship are all tied to the Baltimore docks. The B&O Railroad reached the Ohio River in 1852, opening western markets for Chesapeake Bay oysters. Oyster packers began opening dozens of operations around the Chesapeake Bay to fill the demand from across the United States and even in France and Japan. (Courtesy of the Maryland Historical Society.)

The oyster fleet lines the Pratt Street Wharf in anticipation of a good year of dredging. The buildings to the right would now be the Pratt Street Pavilion of the Harbor Place complex. The long, low building is the location of today's Light Street Pavilion, and the steamboat sits where the USS Constellation is currently located. Tourism has replaced seafood processing as an industry in Baltimore. (Courtesy of the Maryland Historical Society.)

These skipjacks are waiting for the ice to break up so they can begin dredging. They are at the harbor in Solomons, Maryland, around 1930. The skipjacks getting stuck in the ice was a common occurrence since oysters are caught in the winter months. The weather is always a factor. The ice was 15 inches thick in 1905, and you could walk the entire Chesapeake Bay. Repairs could be made while they waited, but no dredging meant no money was coming in. (Courtesy of the Doris Woodburn Johnson Collection, Calvert Marine Museum.)

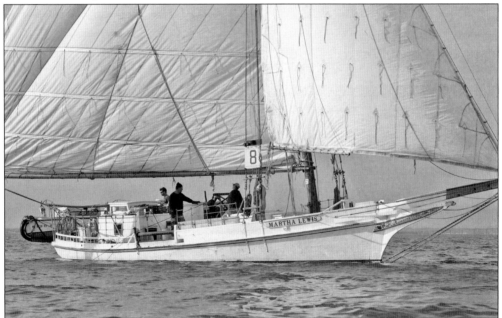

The skipjack *Martha Lewis* is dredging on a calm, warm day. There were winters where the weather was constantly cold with lots of snow, and there were years with average temperatures well above freezing. The Chesapeake Bay is too far south for winters such as they have in New England but too far north to be considered a temperate climate. The skipjack crews would never know what to expect from one day to the next. (Courtesy of Amy Kehring.)

The *J. T. Leonard*, with license number 26, was built in 1882 on Taylor's Island and operated out of Cambridge, Maryland. She is a rare example of a gaff-rigged schooner built on the Chesapeake Bay. Larger schooners, with two masts and three sails, were more common on waters farther north along Long Island and Cape Cod. She was used for oyster dredging during the same boom years as the skipjacks. The oyster season in Maryland runs from November 1 to March 31. (Courtesy of the Chesapeake Bay Maritime Museum.)

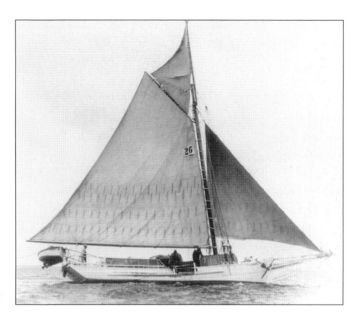

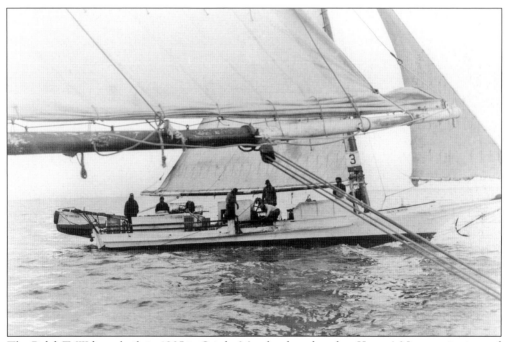

The *Ralph T. Webster*, built in 1905 in Oriole, Maryland, and sunk at Knapp's Narrows, is pictured dredging in 1929. She was already 24 years old. She may be working the oyster reef near Tolchester, Maryland. She sailed for many years with an integrated crew as did many other boats. That was rare for the pre–civil rights era. (Courtesy of the Chesapeake Bay Maritime Museum.)

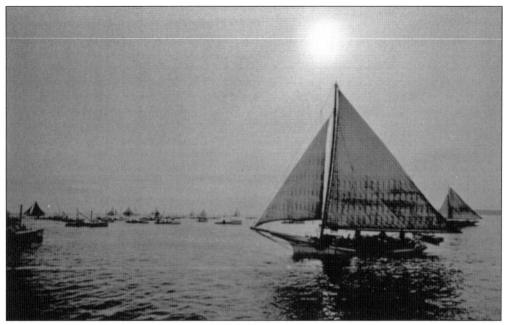

The *Lena Rose* is shown dredging sometime in the early 1930s. There were concerns as early as the 1860s about the life expectancy of the oyster population. Abe Lincoln mentioned the dangers of over-fishing the oyster population while he was president. The whole history of the oyster industry has been one of regulations to make catching them hard in hopes of saving the population. The 1890 Cull Law required the spat, young oysters, to be dropped back on a reef for regeneration. (Courtesy of the Chesapeake Bay Maritime Museum.)

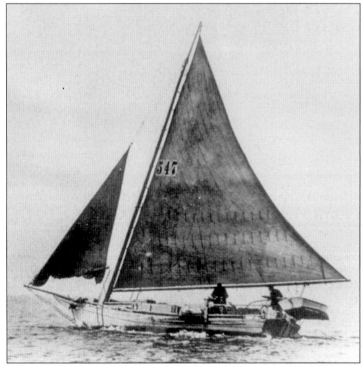

A skipjack is dredging in this undated photograph. The current regulations allow skipjacks to dredge Monday through Friday, with Monday and Tuesday designated as power days. They can dredge from sunrise to sunset on power days, but must stop at 3:00 p.m. on sail days. Certain reefs are restricted to tonging, and many are so covered with silt that they can't be dredged. (Courtesy of the Chesapeake Bay Maritime Museum.)

The *Hilda M. Willing*, dredging the Choptank River, was another Oriole, Maryland, skipjack. She is a designated National Historic Landmark. She cost $3,000 to construct in 1905. A new set of sails and new wood to replace rotting boards in 2005 carried a price tag of more than $35,000. (Courtesy of the Chesapeake Bay Maritime Museum.)

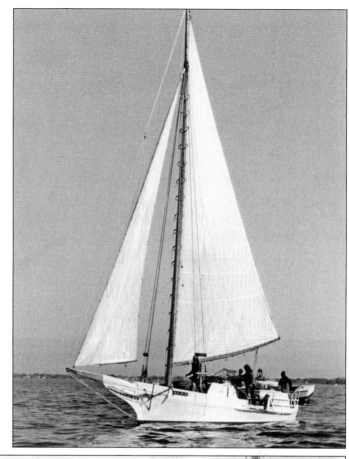

The photograph shows the *Kathryn*, also a National Historic Landmark, dredging under power with license number 21 in plain view. The cable attaching the dredge to the winder is visible. The crew member has his hand on the cable. He can tell by the feel if they are over oysters or mud. (Courtesy of the Library of Congress.)

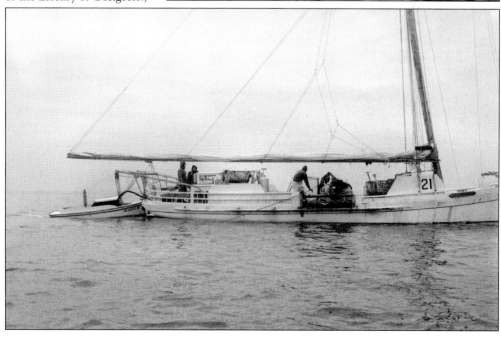

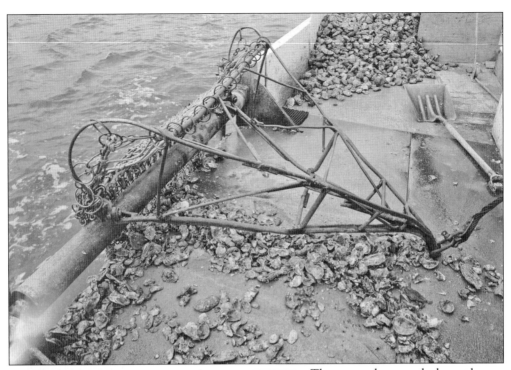

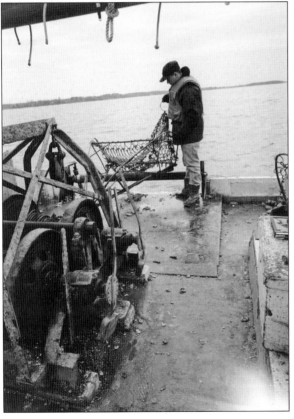

The upper photograph shows the dredge basket balanced on the horizontal roller waiting to be dropped. The coal shovel is used to move the oysters around the deck. A crew member is holding the dredge basket by the rings in the lower photograph, giving him a better grip on the basket, which becomes wet, muddy, and slippery as dredging proceeds. The oyster reefs are referred to as rocks. Each pass across the rock with the dredge baskets out is called a lick. He will lower the basket over the roller when the captain calls for a lick. (Courtesy of the Library of Congress.)

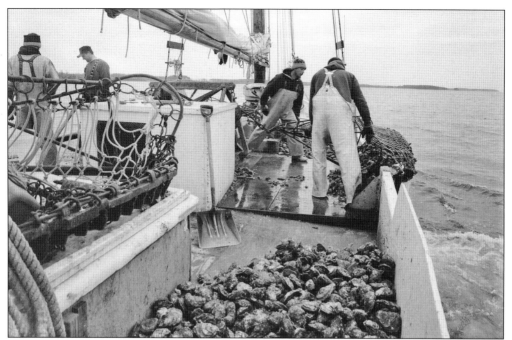

The starboard, or right, dredge basket is being brought on board while on the other side of the boat, the port basket is being lowered by the crew. Dredge baskets are usually alternated to prevent the cables from getting fouled. Plywood sheets, called oyster boards, are placed on the deck of the boat to protect it. (Courtesy of the Library of Congress.)

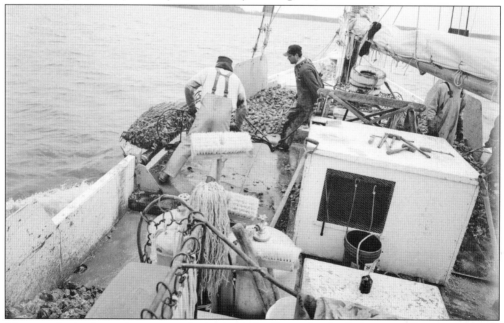

The port dredge is coming up over the horizontal roller with a load of oysters. The crew's culling hammers, used for sizing oysters, are on top of the box containing the dredge motor. The oyster boards protect the boat, but the crew gets wet and cold despite wearing rain gear on even sunny days. (Courtesy of the Library of Congress.)

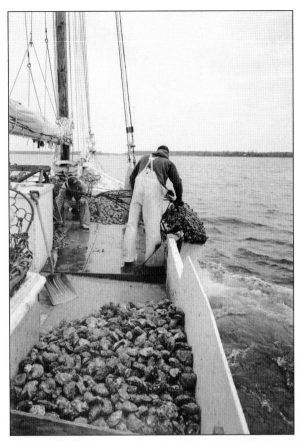

The starboard dredge basket is loaded with oysters. Bushel baskets used to store the oysters are stacked behind the kneeling crew member. A coal shovel used to move the mud and oyster debris back overboard is leaning against the dredge motor box. The keepers are tossed down the deck as they are sized so they will not go back overboard. (Courtesy of the Library of Congress.)

The crew will sort the oysters spilled on the deck, separating the ones they guess to be a legal size from the smaller ones that have to be returned to the reef. Spat are oysters that have just moved beyond the larvae stage and have attached themselves to grow their own shell. The health of an oyster reef depends on the spat being placed back on the oyster bed. (Courtesy of Amy Kehring.)

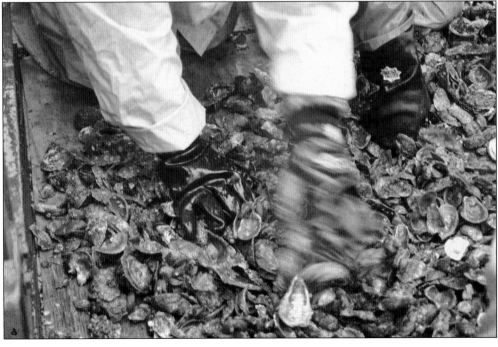

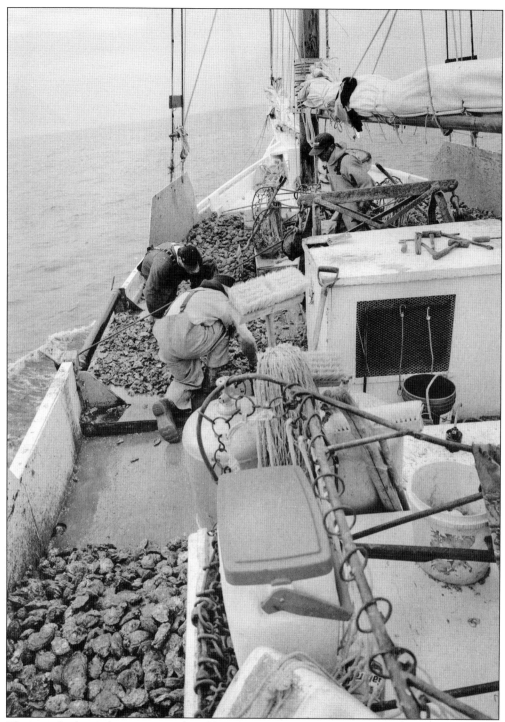

The port basket is being emptied and hand sorted. Dredging is backbreaking work. A crew member is up and down, on and off their knees, lifting the heavy basket and shoveling all day long. They will be soaking wet from the water and mud brought up with the oysters. (Courtesy of the Library of Congress.)

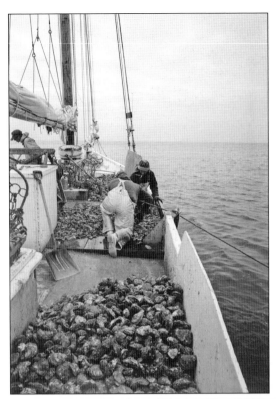

The crew works sorting the starboard basket. The Chesapeake Bay water temperatures during the oyster season are often a few degrees above freezing, and the air temperature can be worse, but a skipjack wants wind to allow faster dredging. They can move in light breezes but are more effective when the wind is around 12 to 15 knots. (Courtesy of the Library of Congress.)

A culling hammer is used to size the oyster, as well as to knock the barnacles off of the shells. Buyers want clean oysters. Legal size in 2007 is three inches across. One hundred years ago, that size would have been thrown back to allow them to grow to an acceptable size. (Photography by the author.)

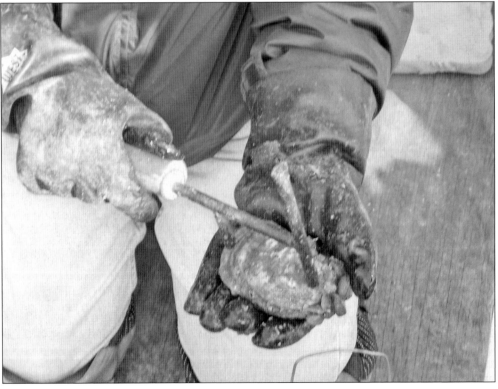

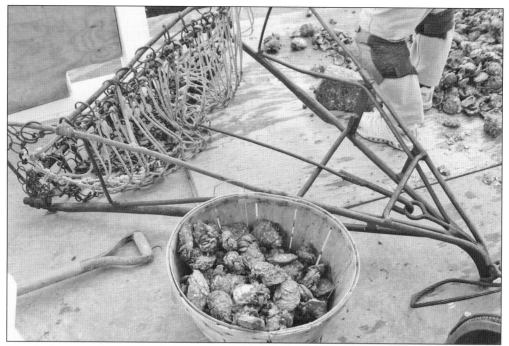

The dredge waits for another lick, and one bushel is almost filled. The first size limitation went in effect with the 1890 Cull Law. Oysters will reach maturity at around one year, but the salinity of the water affects their growth. Years with a lot of rain, which lowers the salt content of the Chesapeake Bay, are bad for oyster population growth. (Photograph by the author.)

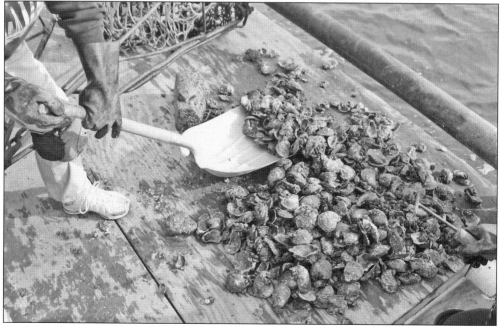

Coal shovels are used to shovel the waste back overboard and to fill the bushel baskets with the keepers from each lick. A skipjack is limited to 150 bushels per day in 2007. Fifty years ago, the limit was 300 bushels and a skipjack often harvested that in an hour. (Courtesy of the author.)

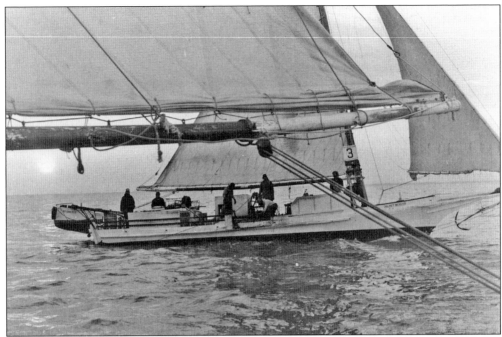

The *Ralph T. Webster* with license number 3 dredges the Choptank River. Maryland has an estimated 250,000 acres of natural oyster reefs, but experts disagree about how many are still productive. Some are covered with silt, lost forever, and beyond any logical hope of recovery. It will take 250 years to complete the restoration of the beds if the money can be found. (Courtesy of the Chesapeake Bay Maritime Museum.)

The Maryland Tidewater Fisheries Police patrol boat *Harford* is watching the skipjacks, looking for violations of the regulations. The unit is now called the Department of Natural Resources Police. The first "oyster police" went out on the water in 1868. They have never been popular with the watermen, and violence, even deaths, were not unheard of during the early years of dredging laws. (Courtesy of Calvert Marine Museum.)

The skipjacks would often sell their oysters without returning to the dock. This unidentified skipjack is along side of a buyboat. It will offer the captain a price for his harvest. The buyboat will take the oysters to shore for processing, selling them for a higher price than they gave the skipjack. (Courtesy of the Chesapeake Bay Maritime Museum.)

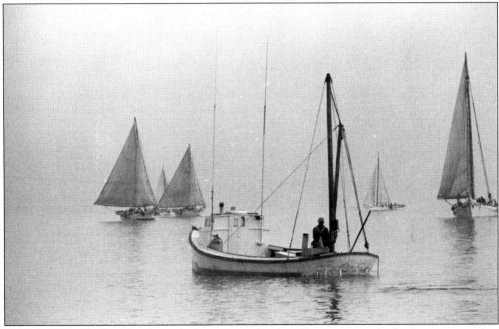

A buyboat approaches the skipjack fleet on a calm day. The crane on the buyboat was used to swing the heavy baskets of oysters on to the buyboat and later onto the dock. Many buyboats were converted from bugeyes by removing the sailing rigs and adding an engine. (Courtesy of the Chesapeake Bay Maritime Museum.)

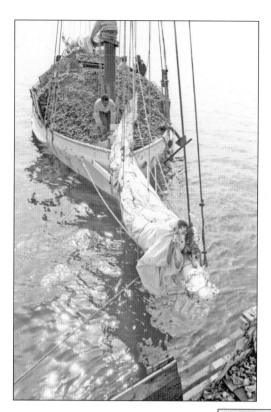

This skipjack has had a good trip. Loads of this size were common as recently as 50 years ago but have all but disappeared in the last 30. The captain on this boat has decided to sell at the dock, where the prices will be higher than those offered by a buyboat. (Courtesy of the Chesapeake Bay Maritime Museum.)

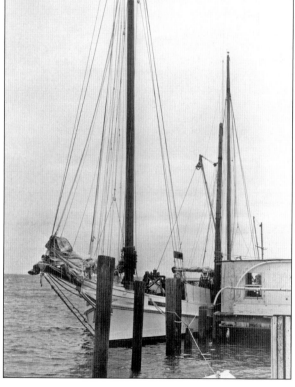

Skipjacks did not always sell to a buyboat. If a significantly better price could be had by selling direct at the dock, and they were close, the captain might head in with the harvest. The skipjack *Martha Lewis* is shown unloading at Knapp's Narrows on Tilghman Island. (Courtesy of the Chesapeake Bay Maritime Museum.)

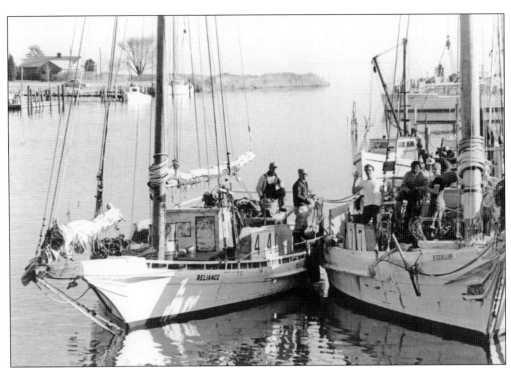

The *E. C. Collier* and the *Reliance* are unloading at Knapp's Narrows, once home to dozens of skipjacks. The term "narrows" refers to a natural strip of water that separates the mainland from an island. Knapp's Narrows is 10 miles past the town of St. Michaels in Talbot County, Maryland. The *Rebecca T. Ruark*, for example, still docks near Knapp's Narrows in Dogwood Harbor. (Courtesy of the Chesapeake Bay Maritime Museum.)

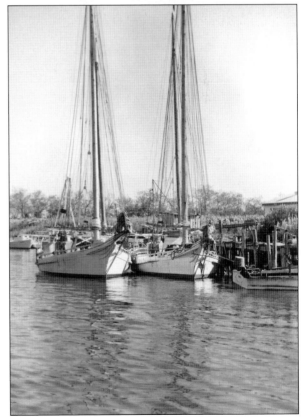

An unidentified skipjack is at Knapp's Narrows. It was a major location for oyster packers. They have been replaced by upscale bed-and-breakfasts that serve the tourist trade, now the main industry on Maryland's Eastern Shore. Knapp's Narrows is still a popular starting point for fishing charters on the Chesapeake Bay. (Courtesy of the Chesapeake Bay Maritime Museum.)

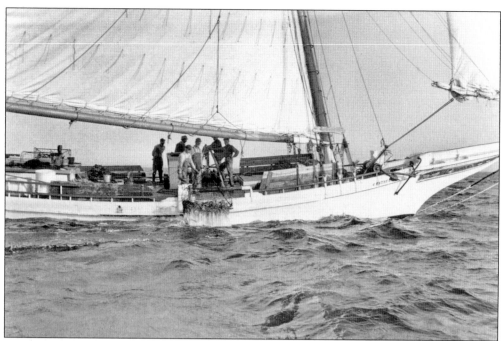

A skipjack crew watches a dredge come on board. The boat is either the *Esther W.* or the *Esther F.*, but regardless, her dredging days are long past. The crew members would have been among the last of their family to make a living harvesting oysters. A lifestyle that went unchanged for a several generations has disappeared along with the oysters and the skipjacks. (Courtesy of the Chesapeake Biological Laboratory Collection, Calvert Marine Museum.)

An unidentified skipjack is dredging under sail somewhere on the Chesapeake Bay. The National Trust for Historic Preservation added the skipjack to their 2002 list of America's Most Endangered Historic Places. Efforts to save the state symbol of Maryland, and the oyster, continue, but it takes time, money, and desire, qualities that are often diverted to other interests. (Courtesy of the Chesapeake Bay Maritime Museum.)

Five

THE CHESAPEAKE BAY OYSTER

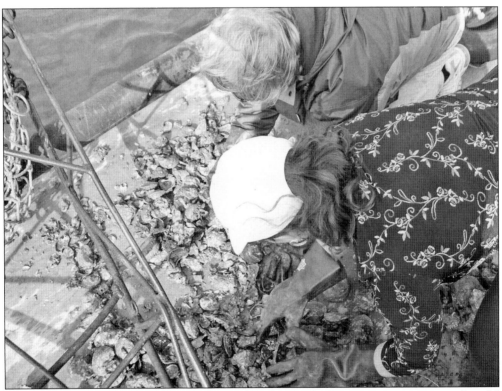

The *crassostrea virginica*, the official name of the Chesapeake Bay oyster, were once so plentiful that they filtered all 15 trillion gallons of water in the estuary in two days. The early settlers describe oysters the size of dinner plates. The legal size today is three inches in length. (Courtesy of the author.)

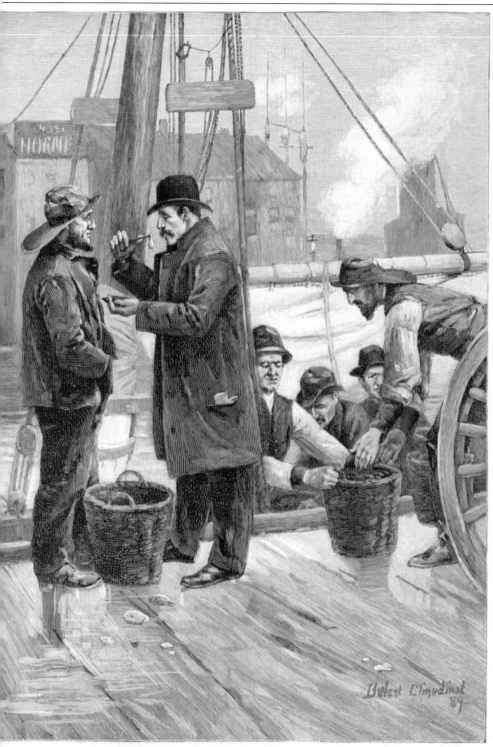

AN OYSTER SPECULATOR TESTING A CARGO.

THE MARYLAND OYSTER BUSINESS.—Drawn by B. West C

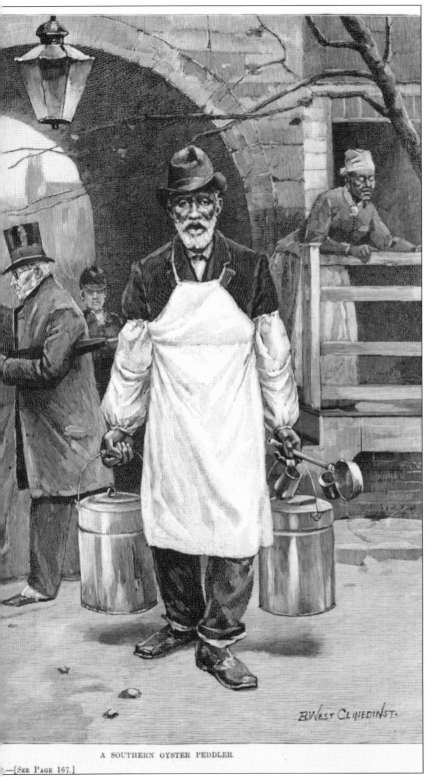

A SOUTHERN OYSTER PEDDLER.

—[See Page 167.]

The left side of this print from the 1800s shows a crew unloading a skipjack while the captain negotiates with a buyer. A writer in 1701 said the oysters from the Chesapeake Bay were four times as large as any he had seen in England, and he often had to cut them in two before putting them in his mouth. An employee of a cannery is carrying the oysters in pails on the right side. It is hard to overstate the importance of the oyster to the economy of the state of Maryland in the latter half of the 1800s. The population in 2007 is one percent of what it was when the first English settlers arrived. (Courtesy of the Maryland Historical Society.)

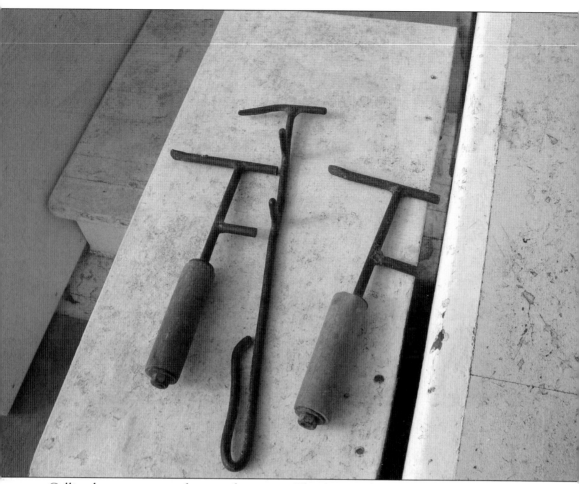

Culling hammers are used to size the oysters. The distance between the two prongs is three inches, and the oyster can not fit inside of the prongs to be considered legal. If it is too small, it is returned to the reef. The legal size in 2007 would have been thrown back as recently as the early 1970s. (Photograph by the author.)

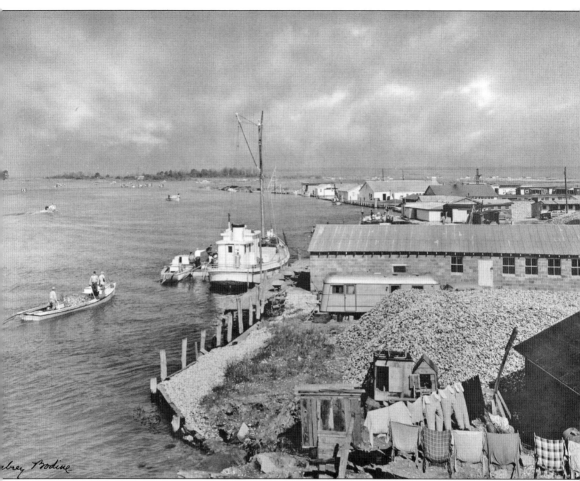

The eastern or Atlantic oyster is usually found in water depths between 8 and 25 feet, depths common in the Chesapeake Bay. W. K. Brooks in his 1905 book, *The Oyster*, wrote, "Our [Maryland's] oyster beds are our greatest source of wealth." The controversy over bottom leases to protect the oysters and the public right to harvest them has raged for more than 100 years. These are the shell remains piled on Deal Island during the 1950s. (Photograph by A. Aubrey Bodine, © Jennifer Bodine; Courtesy of www.AAubreyBodine.com.)

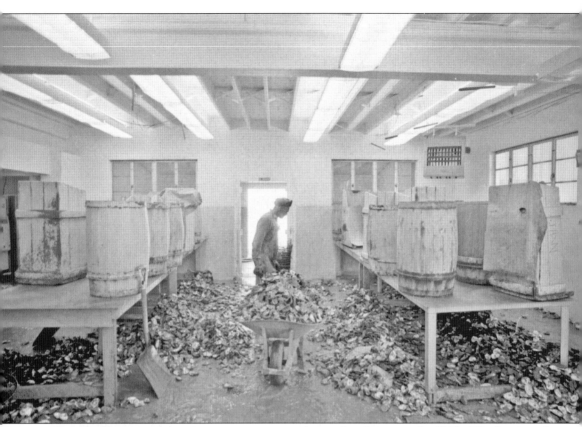

The wheelbarrow is bringing more oysters into this packinghouse in the 1930s. The history of the oyster industry has been one of introducing inefficiency at every step of the way in hopes of prolonging the supply and keeping harvests profitable. (Courtesy of the Chesapeake Bay Maritime Museum.)

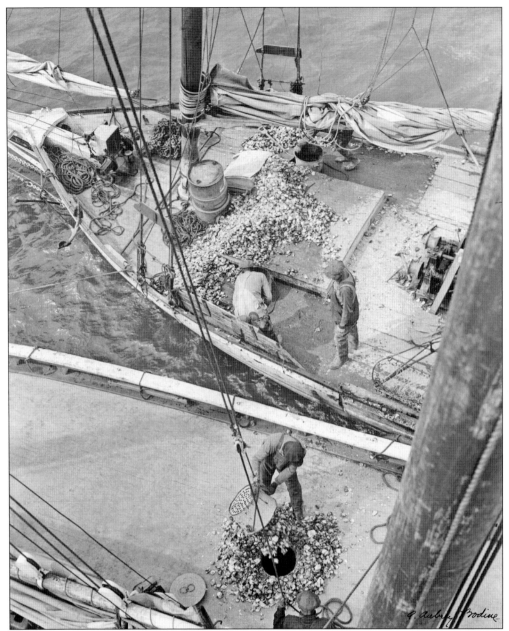

The skipjacks and a buyboat are dividing the catch in 1940. For over a century, the harvest was measured in the millions of bushels. As recently as the 1940s and 1950s, a skipjack could easily harvest 200 to 300 bushels a day. The concern over the loss of the oysters in the Chesapeake Bay is an example of an early environmental issue that created as much controversy as global warming does today. The two sides were often divided along political lines. Many unpopular steps were taken, but no one anticipated the arrival of two parasites in the 1950s. MSX and Dermo have further depleted the populations. (Photograph by A. Aubrey Bodine, © Jennifer Bodine; Courtesy of www.AAubreyBodine.com.)

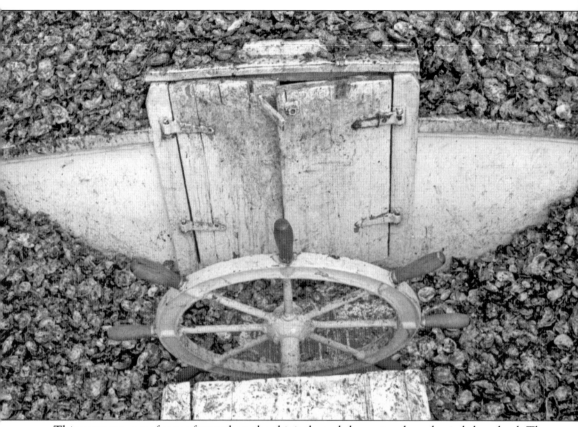

This crew ran out of room forward on the skipjack, and the oysters have buried the wheel. The lack of oysters has doomed the skipjacks. The concerns of the 1860s have proven prophetic. One early writer claimed the skipjacks were introduced to scavenge over the remains of an already dead industry. Many people believe public funds are being spent to maintain a traditional way of life that is no longer practical. That is not always a popular choice among tax payers, but a healthy oyster population can be a significant contributor to broader efforts to restore the Chesapeake Bay. Many have been put in place by private organizations such as the Chesapeake Bay Foundation. (Courtesy of the Chesapeake Bay Maritime Museum.)

The *Maime Mister*, built in 1910 and sailing from Chance, Maryland, is heading in with a full load of oysters. This starboard view shows the yawl boat pushing the skipjack, and her skiff is being towed. Harvests of this size will never be seen again, but efforts continue to bring the oyster population back to acceptable levels. (Courtesy of the Chesapeake Biological Laboratory Collection, Calvert Marine Museum.)

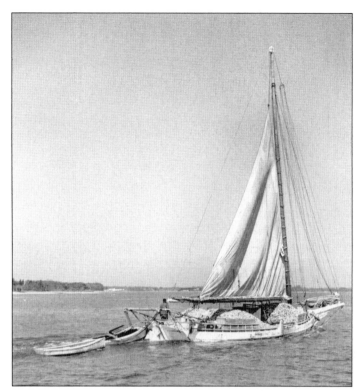

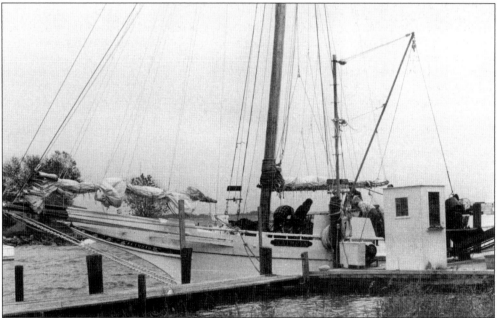

The *Kathryn* is unloading at Knapp's Narrows. She has been restored and is a National Historic Landmark that still sails under the firm hand of Capt. Russell Dize. She was originally built in 1901 at Crisfield, Maryland, by J. E. Dougherty. There are less than 100 watermen still making a living harvesting oysters. The largest industry in Maryland during the latter half of the 19th century is effectively gone. (Courtesy of the Chesapeake Bay Maritime Museum.)

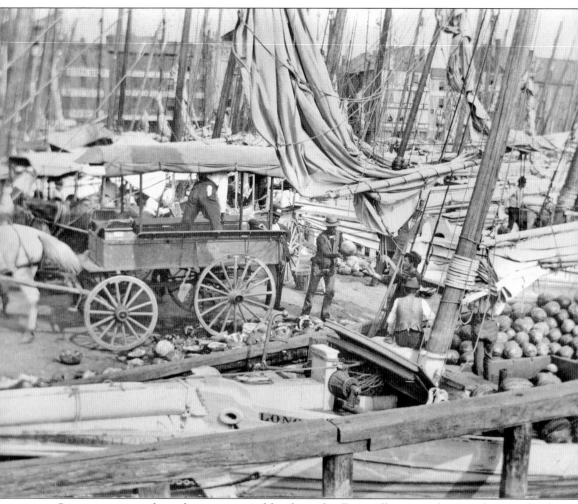

Oysters were not the only cargo carried by skipjacks. Fruit sellers are selecting their stock of watermelons from a skipjack in Baltimore Harbor around 1897. The farms on the Eastern Shore found the skipjacks were the perfect way to get produce cheaply and quickly across the Chesapeake Bay to the large markets on the western side. (Courtesy of the Maryland Historical Society.)

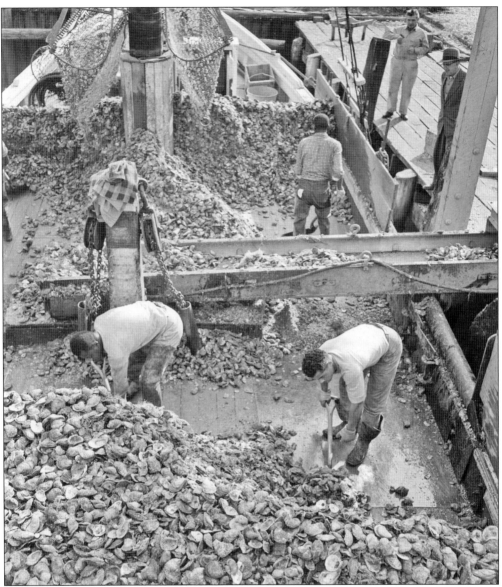

The oysters are being unloaded from the skipjack. The first oyster packinghouse was built in 1828 in Baltimore. The industry became so large, and important, that refrigerated railcars were developed to move the oysters inland. The market for the Chesapeake Bay's oysters stretched across both the Atlantic and the Pacific Oceans. Major shipments were sent to Europe and Japan. French chefs liked to use the Chesapeake Bay oyster in many of their dishes. They were served in the finest restaurants in New York, Chicago, and San Francisco and were a staple of many dinners served at the White House. (Photograph by A. Aubrey Bodine, © Jennifer Bodine; Courtesy of www.AAubreyBodine.com.)

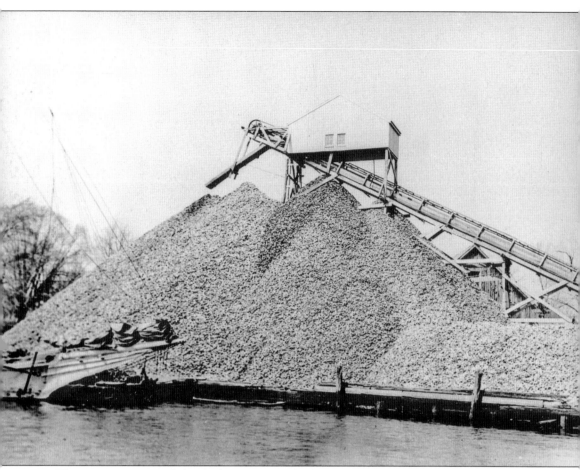

The conveyors carried the fresh oysters inside the oyster packinghouse and brought out the shells. The bow of a skipjack is seen at left. There was close to 1,000 packinghouses around the Chesapeake Bay in the late 1800s. Most oysters now consumed in Maryland come from another part of the country. Eastern oysters are found in many states but were never as plentiful in other locations as they were on the Chesapeake Bay. The industry, which is essentially gone, was the prime economic engine of Maryland during the late 1800s and up until World War II. (Courtesy of the Elgin A Dunnington Jr. Collection, Calvert Marine Museum.)

Six

WATERMEN

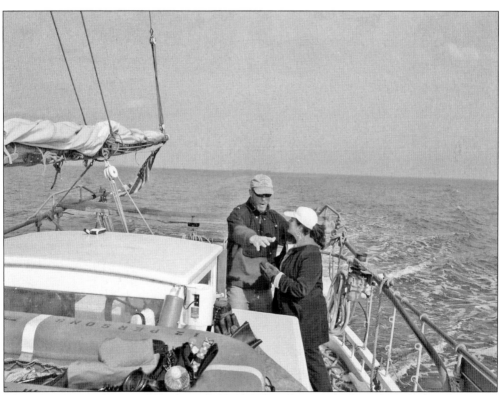

The captain is in charge of the skipjack. He decides where to dredge, when, for how long, and where to sell. The skipjack captain must be an excellent sailor, have a vast store of knowledge about the Chesapeake Bay and its bottom, be a good forecaster of the weather, and be someone with whom a crew wants to work. This is Capt. Greg Shinn, the eighth captain of the *Martha Lewis*, explaining the processing of dredging for oysters to a volunteer crew member. (Courtesy of the author.)

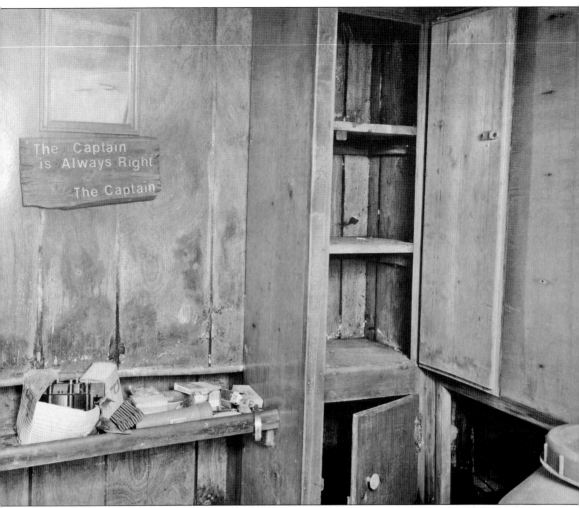

A look inside the cabin of the *E. C. Collier* shows a sign reminding the crew who is the boss out on the water. They would spend many days together and had often known each other for their entire lives. The Eastern Shore skipjack crews tended to come from small towns and were often relatives or close neighbors. The work was hard, and the hours were long. (Courtesy of the Library of Congress.)

The crew on the *Dee of St. Mary's* is hoisting the jib, or fore sail. She was built in 1979 in Piney Point, Maryland, the first skipjack built on Maryland's western shore in over 25 years. Capt. Jack Russell, her owner, gives environmental and natural history tours aboard her. Sails need to be trimmed, or adjusted, depending on where the skipjack is in relation to the wind. The captain will have the crew tighten or ease lines until he is satisfied the boat is sailing with maximum efficiency and in the direction he wants to go. (Courtesy of the Patuxent River Folklife Project Collection, Calvert Marine Museum.)

The crew on this unidentified skipjack is reefing the jib. Reefing is reducing the size of the sail in response to higher winds. A skipjack is easily overpowered because of her shallow draft and large sail area. The crew lowers the sail partway and then rolls and ties the bottom of the sail using short lines inserted through the sail. (Courtesy of the Chesapeake Bay Maritime Museum.)

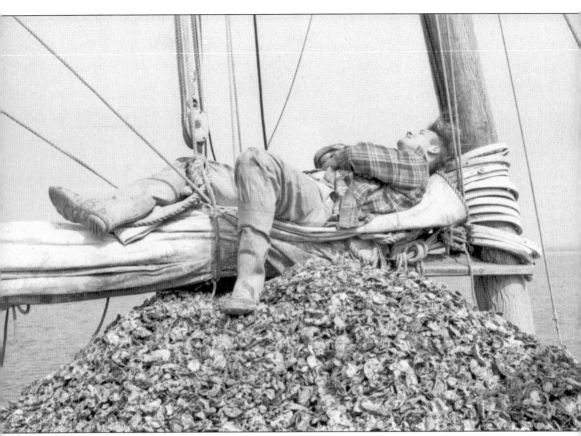

This man is getting some sleep before the dredging begins again. Stories are told that crew members were sometimes "paid off with the boom;" They were knocked overboard and left behind to drown. More likely, the combination of cold, wet, and wind, along with the physical lifting that tires out even the strongest man, led to crew members jumping ship for easier work on land. (Courtesy of the Chesapeake Bay Maritime Museum.)

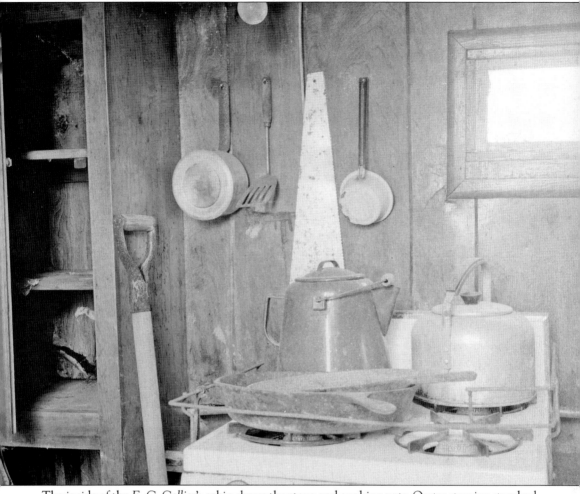

The inside of the *E. C. Collier's* cabin shows the stove and cooking pots. Oyster stew is a standard meal of choice, since the ingredients are being caught as the crew works. Coffee is the drink of choice because of the cold air they work in every day. (Courtesy of the Library of Congress.)

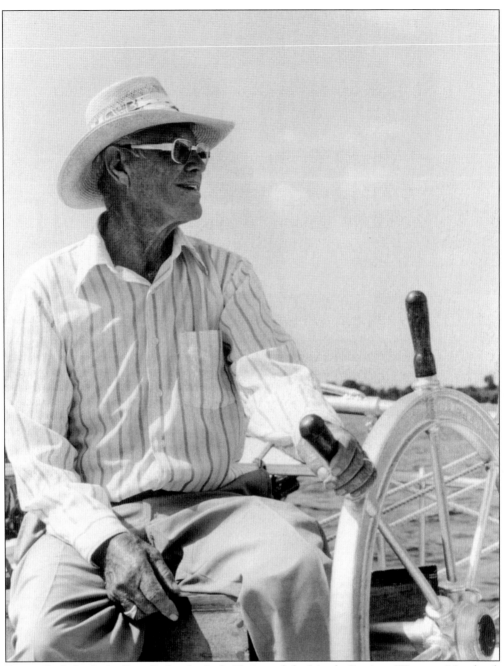

Bronza Parks built the *Rosie Parks*, the *Lady Katie*, and the *Martha Lewis* in Wingate, Maryland. These three skipjacks were among the last built with the expectation they would be working vessels. The three survive—the *Martha Lewis* in Havre de Grace, the *Rosie Parks* at the Chesapeake Bay Maritime Museum, and the *Lady Katie* is in Cambridge. Capt. Orville Parks, brother of Bronza and the first captain of the *Rosie Parks*, is shown in this photograph from the 1950s. He loved to race her and won many contests over the years. Bronza was shot dead at his desk in 1958 by a disgruntled buyer. (Courtesy of the Calvert Marine Museum.)

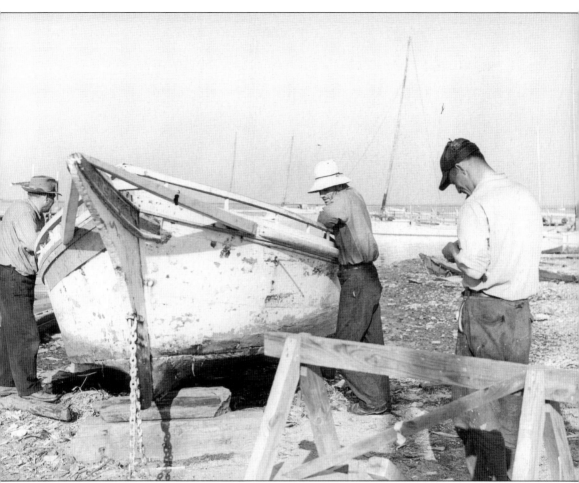

The skipjacks wait in the background as an unidentified boat is hauled for repairs on Deal Island in May 1940. Halley Abbey, a local skipjack and wooden boat builder, is shown on the left. The two other men near the boat are unidentified. Summer was the time to replace rotting boards and worn rigging, but the captains and owners often waited until the last possible minute before spending any money. (Courtesy of the Library of Congress.)

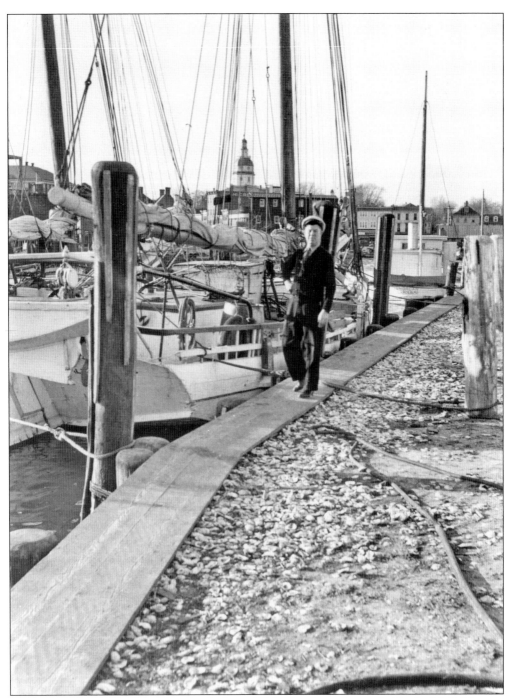

A crew member walks the Annapolis docks in 1938. The skipjack is probably the *H. S. Morgan.* A buyboat is docked ahead, and the rotunda of the Maryland state capital building is in the distance. It must have been a good harvest since he looks to be dressed for a night on the town. A waterman was a good job for many years. It was hard work, but you were outside, on the water, and a man could make a decent living, though the introduction of the skipjack came at the same time the work became less lucrative. (Courtesy of the Library of Congress.)

Seven

SKIPJACKS TODAY

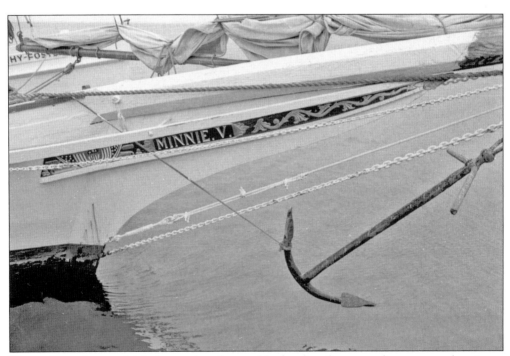

The trailboards on a skipjack were hand-carved by local craftsmen and were more than just a place for the skipjack's name. They added color to the otherwise white vessels, usually had a patriotic theme, and were a symbol of the pride the captains took in their boat. The *Minnie V.*, built in 1906 in Wenona, Maryland, still sails. She is owned by the Living Classroom Foundation in Baltimore. (Courtesy of the Chesapeake Bay Maritime Museum.)

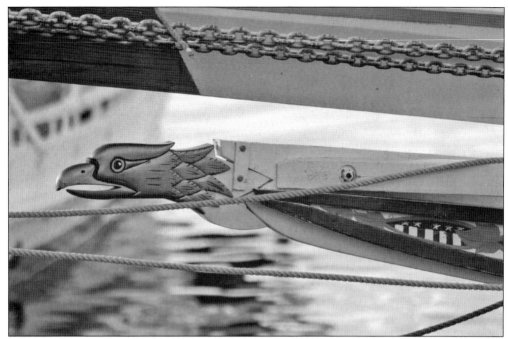

Visible is a hand-carved eagle on the *Nathan of Dorchester*. It took volunteers three years to build the 65-foot skipjack. She was finished in 1994 and was part of an effort to preserve the skipjacks and the methods used to build them. She sails out of Cambridge, Maryland. (Courtesy of Amy Kehring.)

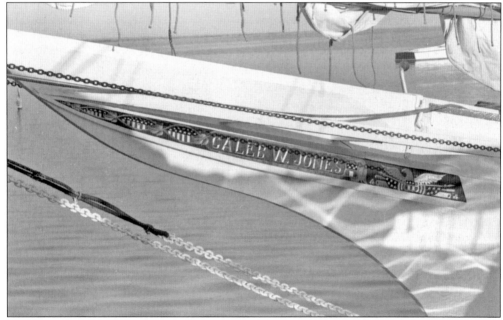

The skipjack *Caleb W. Jones* is another survivor. She was built in Reedville, Virginia, in 1953 by C. H. Rice, who also built the more well-known *City of Crisfield*. The *Caleb W. Jones* dredged as recently as the 2005–2006 season. The Web site Skipjack.net has an excellent article about dredging aboard her. (Courtesy of the Chesapeake Bay Maritime Museum.)

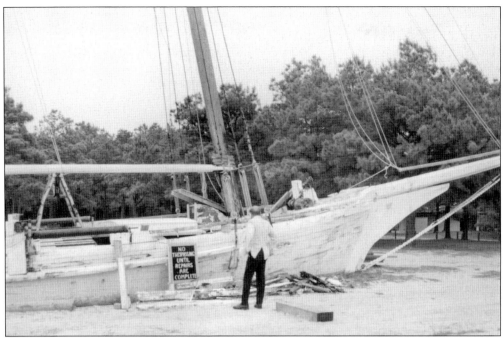

The *Wilma Lee* was restored by Herb Cardin in 1994. She was built in Wingate, Maryland, in 1940 but now sails out of the Virginia side of the Potomac River. She is an earlier boat built by Bronza Parks. She dredged in the 2005–2006 season. (Courtesy of the Chesapeake Bay Maritime Museum.)

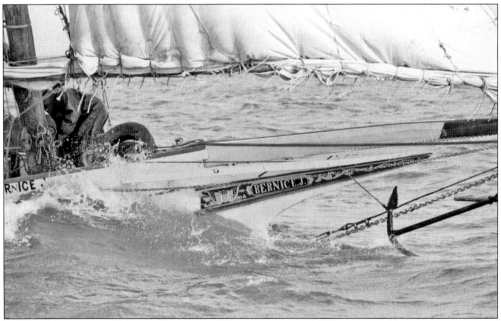

The *Bernice J.* was broken apart in 1999 at the age of 95. Accomac County, Virginia, was her original home. She had been on the list of the National Register of Historic Places and sailed out of Chestertown, Maryland. The expense of upkeep became too much, and no one stepped forward to save her. (Courtesy of the Chesapeake Bay Maritime Museum.)

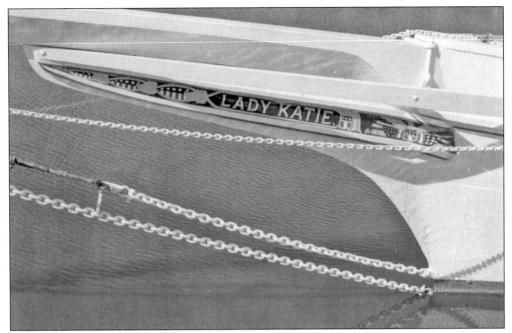

The *Lady Katie* is a Bronza Parks boat built in Wingate in 1956. She is one of nine that has undergone restoration as part of a skipjack project introduced at the Chesapeake Bay Maritime Museum in 2001. A 72-foot tree was found to form her new mast. She is kept in Cambridge, Maryland. (Courtesy of the Chesapeake Bay Maritime Museum.)

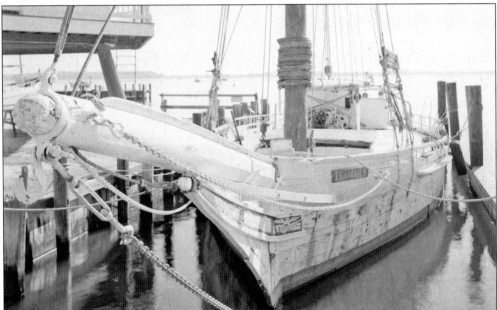

The *E. C. Collier* has been at the Chesapeake Maritime Museum since 1975. She was built by G. W. Horseman on Deal Island in 1910, one of the glory years for constructing skipjacks. She is 52 feet long and carries a beam of almost 18 feet. The overall length of a 50-foot skipjack can exceed 80 feet because of the bow sprit and the davits for the push boat on the stern. (Courtesy of the Library of Congress.)

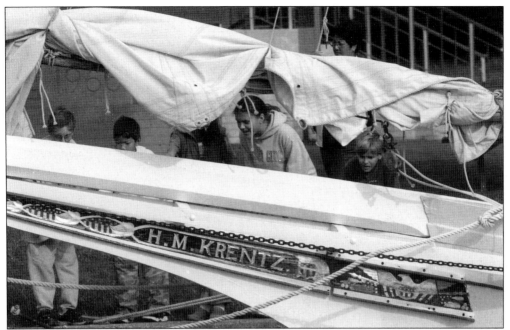

The skipjack *H. M. Krentz* was built in Harryhogan, Virginia, in 1955 and still sails, offering charters from St. Michaels, Maryland. She is 49 feet long on deck, but 70 feet overall with a width at the beam of 15 and a half feet. She was a participant in the 2007 skipjacks races in Cambridge, Maryland. (Courtesy of Amy Kehring.)

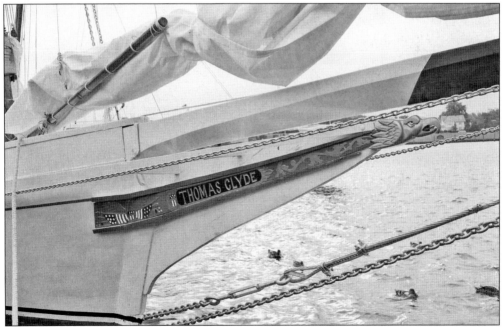

Here is an example of a skipjack launched in 1911 in Oriole, Maryland, that is still with us in 2007. The *Thomas Clyde* has gone through restoration at the Chesapeake Bay Maritime Museum's program. She measures 20 feet at the beam and is one of the larger skipjacks constructed. (Courtesy of Amy Kehring.)

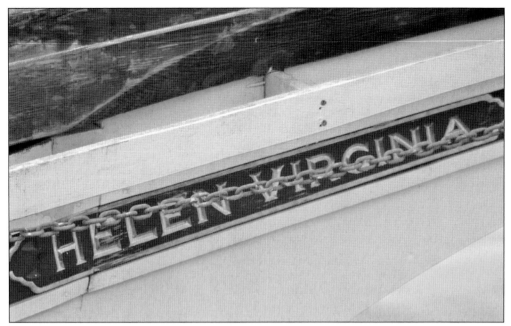

Pictured is the *Helen Virginia*'s trailboard. Despite her name, she was built in Crisfield, Maryland, in 1949 by G. Forbush and has since been restored. This photograph was taken during her participation at the Deal Island races in 2006. She now sails out of Cambridge, Maryland, with Ernie Barlow as captain. (Courtesy of Amy Kehring.)

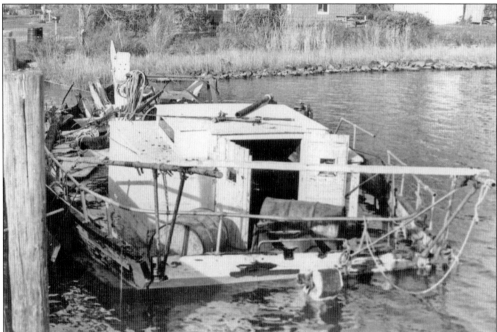

The *Geneva May*, built in 1908, is dying on Tilghman Island. She has been stripped of her mast, boom, and rigging, but the dredge winders remain. She is also featured in a painting by John MacLeod that shows her sailing near Ragged Point at the mouth of the Potomac River. (Courtesy of the Chesapeake Bay Maritime Museum.)

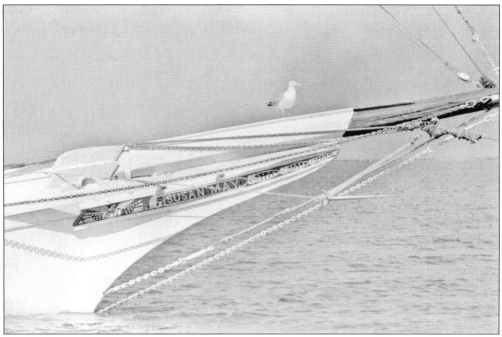

The *Susan May* was abandoned at Wenona, Maryland, a victim of the oyster dredging economics. She was built in 1901 at Pocomoke City, Maryland. She was constructed with fore and aft planking instead of the more common method of driving the bottom planks at a 90-degree angle to the centerline. The below photograph shows her sitting derelict on Deal Island. Her license, number 49, is still attached to the shrouds. Visitors to the Eastern Shore of Maryland are often bothered by the native habit of throwing things no longer needed into the shallow water. The well-known Chesapeake Bay writer Tom Horton discusses it at length in his book about life on Smith Island, *An Island Out of Time*. (Courtesy of the Chesapeake Bay Maritime Museum.)

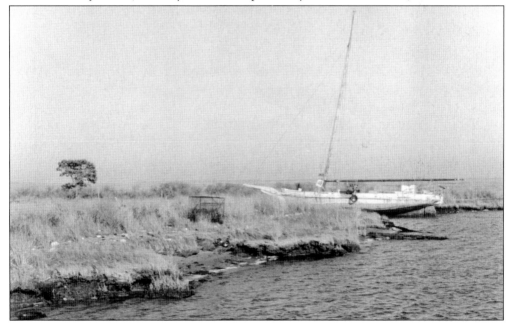

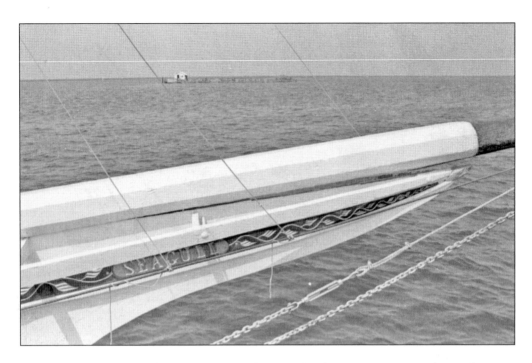

Crisfield has long been the capital of Maryland's seafood industry for many years, first with oysters and in more recent years with blue crabs, especially soft-shelled ones. The *Seagull* was constructed there in 1924 and was broken apart in 1993. The upper photograph shows her freshly painted bow sprit and trailboard, while the lower shows her rotting away in the waters near Oriole, Maryland. She is featured in a well-known painting by the Chesapeake Bay artist John MacLeod entitled "Skipjack Seagull Abandoned." (Courtesy of the Chesapeake Bay Maritime Museum.)

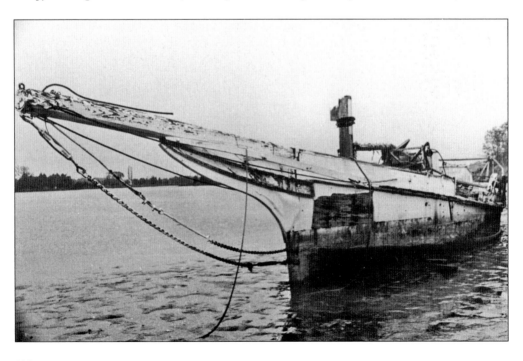

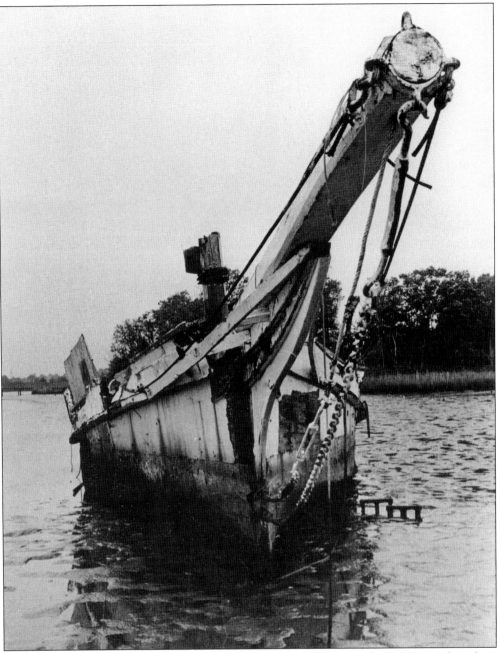

This unidentified skipjack could be the *Lorraine Webster*. She was a Reedville, Virginia, boat from the late 1940s that was sunk at Knapp's Narrows. It could be the *Howard*, the *Clarence Crockett*, the *Ruby G. Ford*, or any number of other vessels that simply disappeared without a trace. (Courtesy of the Chesapeake Bay Maritime Museum.)

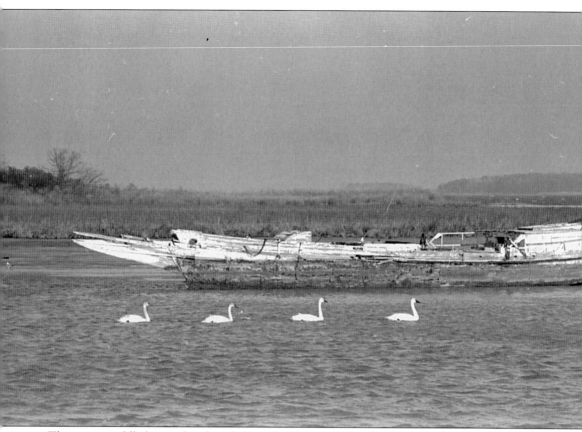

The swans paddle by an abandoned skipjack. This might be the G. A. *Anderson*, left to rot in Rock Hall, Maryland, home to many non-native tundra swans. The skipjack crews were not the best at keeping records. The boats were simply left behind when they had served their purpose. No one believed that people in the future would long for their return. They are now one of the most popular tourist attractions around the Chesapeake Bay. Skipjacks in Havre de Grace, Baltimore, Cambridge, St. Michaels, Tilghman Island, and other locations all do a variety of cruises for paying passengers. (Courtesy of the Chesapeake Bay Maritime Museum.)

The birds have found a use for the skipjack in the upper photograph. Her identity and final resting place is unknown. The only part of her showing is the cabin. The one in the second photograph once dredged for oysters under license number 56. The skipjacks have become a symbol of a time that has past. We now try and preserve things that were considered worthless because we thought they would always exist. These images by Robert de Gast are from a series he did in the early 1970s. He produced an excellent book about the skipjacks full of his great black-and-white photographs, but he became so disillusioned about the future of the Chesapeake Bay, oysters, and skipjacks that he moved to Mexico several years after publishing his book. (Courtesy of the Chesapeake Bay Maritime Museum.)

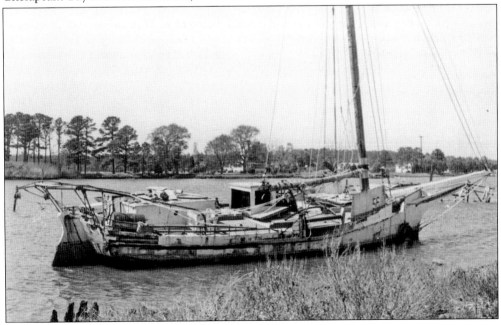

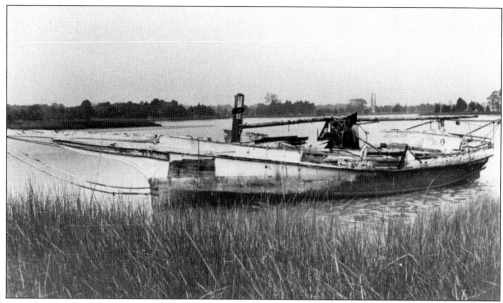

Here is another skipjack that will never dredge again. Hundreds of these magnificent boats were pulled into the mud flats and left for nature to deal with. Some were dismantled and the wood used for other boats, or other projects, but most were simply forgotten. The men who used them moved on to other boats, other jobs, or other places. (Courtesy of the Chesapeake Bay Maritime Museum.)

An entire cove is filled with abandoned and derelict boats. Crab boats, bugeyes, and skipjacks are among those in the photograph. The first bugeye built in 50 years was launched in the spring of 2007. Few of them survive from their working days. Most became power-driven buyboats that were later abandoned. (Courtesy of the Chesapeake Bay Maritime Museum.)

The surviving skipjacks number less than 30. This leaves over 900 unaccounted for and lost to history, including this one at Champ, Maryland. These photographs are old enough that the wooden frames will now have disappeared entirely. There would no longer be any visible evidence they existed. (Courtesy of the Chesapeake Bay Maritime Museum.)

The *Geneva May* lies dead at a dock on Deal Island. It takes time and money to restore a wooden boat of any kind and even more so because the skipjacks were built as working boats with simple construction methods and low-cost materials. The builders never thought about their creation surviving into the 21st century. (Courtesy of the Chesapeake Bay Maritime Museum.)

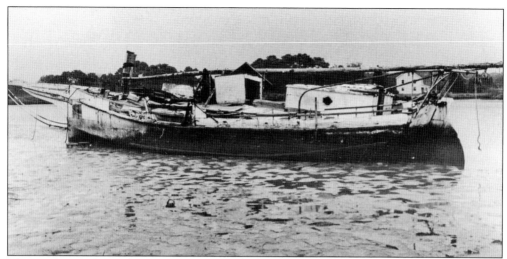

This unidentified skipjack has suffered the same fate as most of these vessels, pulled into shallow water and left to rot. This vessel is on a mud shoal somewhere on Maryland's Eastern Shore. The tide is obviously out, but she is not waiting for high water. Her days are finished. (Courtesy of the Chesapeake Bay Maritime Museum.)

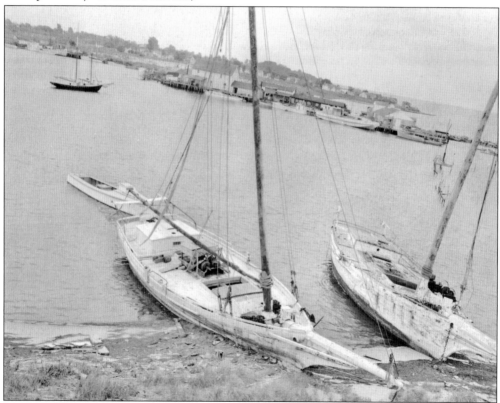

The bows rest on shore, but the rest of the hulls are settling into the water. The boat on the left may still have been active when this photograph was taken. The Eastern Shore was littered with boats that no longer sailed. The lucky ones were found and rescued by people with the money, time, energy, and foresight to save them. (Courtesy of the Chesapeake Bay Maritime Museum.)

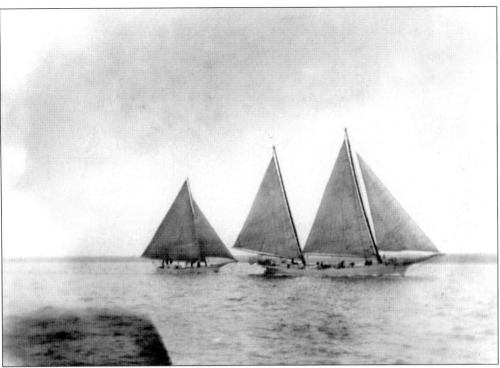

One thing the survivor skipjacks enjoy is racing. Races are held at Deal Island and in Cambridge every year. They are hard to sail but fun because they move fast when everything is set correctly. They are also more stable than many other styles of traditional sailboats because of their wide beams. (Courtesy of the Chesapeake Bay Maritime Museum.)

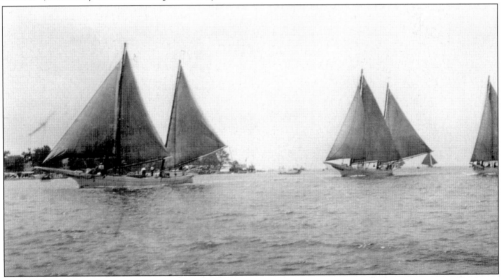

The captain and crews may love the competition, but skipjacks are not sports cars. They are workhorses, and attempts at close-quarter maneuvering can result in disaster. A full turn takes planning, speed, plenty of room, and coordination. These six boats appear to be racing downwind, and one is being left far behind. Both photos are from a race in 1925. (Courtesy of the Chesapeake Bay Maritime Museum.)

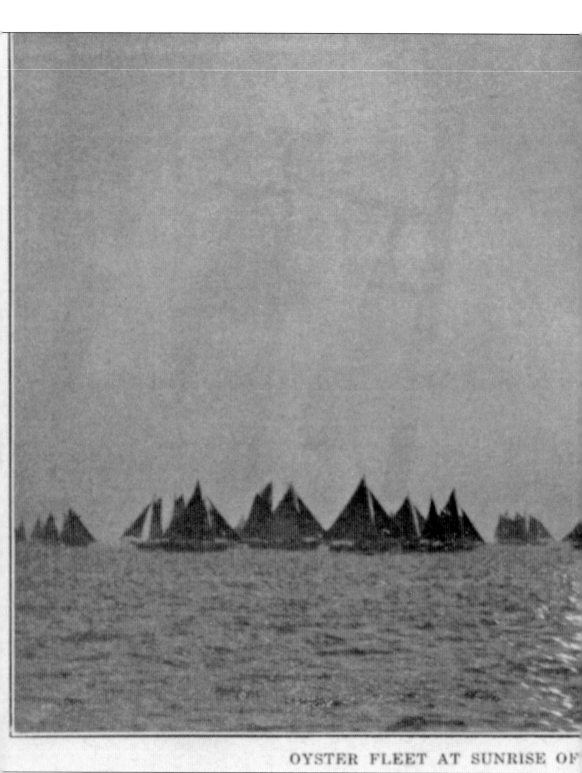

OYSTER FLEET AT SUNRISE OF

These skipjacks race through a fall sunrise off the Patuxent River in 1926. Nine of the surviving skipjacks raced at Deal Island and six at Cambridge on the Choptank River in the fall of 2007. That's

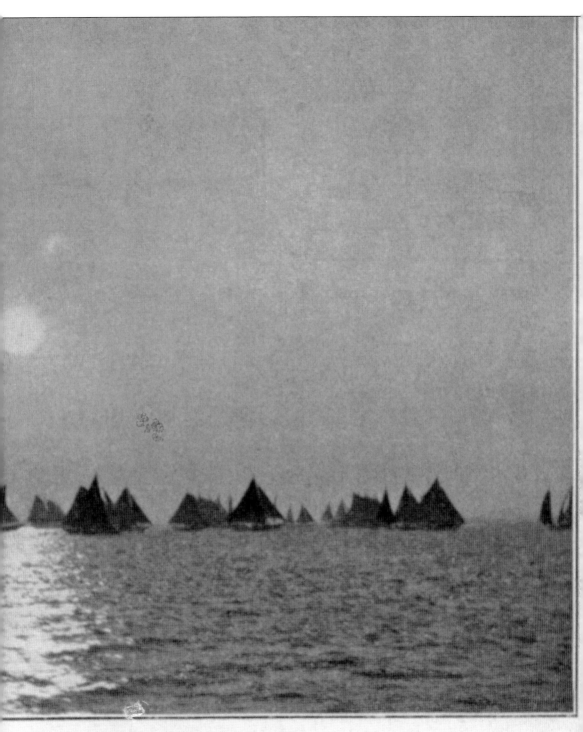

close to every skipjack that still is capable of sailing. Some survive but are so tender that actually using them would cause serious damage. (Courtesy of the Chesapeake Bay Maritime Museum.)

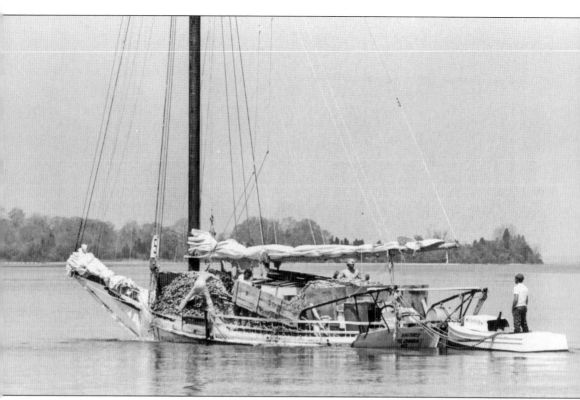

Multiple efforts to restore the oyster population on the Chesapeake Bay have been introduced. Species that are more disease resistant than the Eastern oyster have been laid over the old shells. The skipjack *Sigsbee*, built in 1901, is loaded with seed oysters for planting in the Patuxent River. Capt. Wade Murphy is directing the operation from the push boat in April 1983. This *Sigsbee*, broke apart seven years later. A complete replacement was built in 1994 and is part of the Living Classroom Foundation in Baltimore. (Courtesy of the Patuxent River Folklife Project Collection, Calvert Marine Museum.)

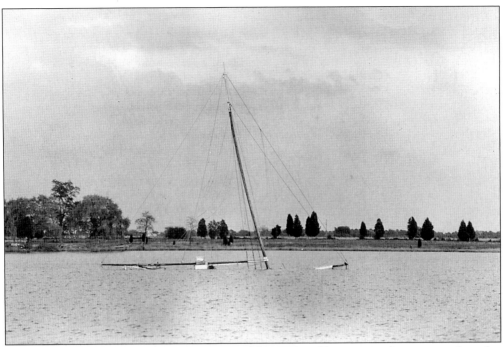

Marylanders have realized an important part of their cultural history was disappearing. It took a "come from," as outsiders are known on the Eastern Shore, to remind people that these beautiful sailing vessels would soon be gone. James Michener's novel *Chesapeake* was only one step in a process of recognition. Skipjacks are one of the most iconic symbols of the Chesapeake Bay. Maryland designated the skipjack as its official boat in 2000. They are part of a living link back to a key time in Maryland's history, a time when it seemed oysters would be there forever and skipjacks would always to be needed to find them.

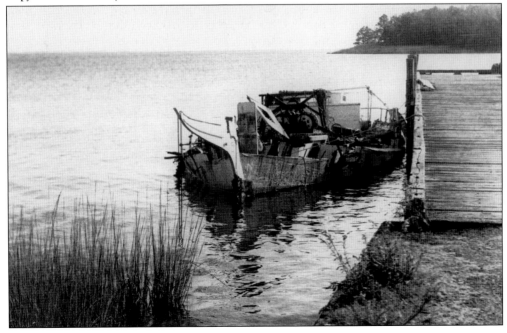

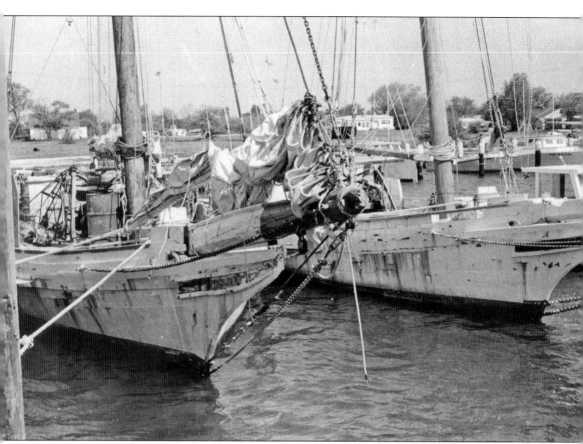

Two skipjacks are waiting at the dock. Their sails are uncovered, and they are ready to go sailing. These simple vessels were never meant to last. They are working boats, and the fact that they are used shows in the photograph. They were built cheap, sailed hard, and then abandoned when it became less expensive to build a replacement, but they have become an important part of Maryland history, a part you can actually participate in. Important steps have been taken to preserve this for future generations, but it continues to be a battle against the forces of time. (Courtesy of the Chesapeake Bay Maritime Museum.)

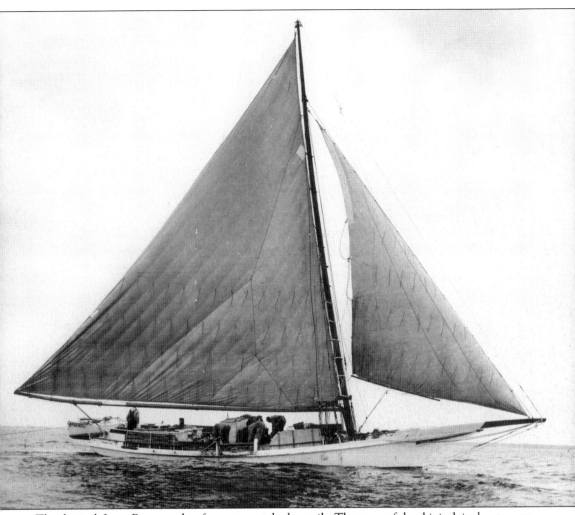

The skipjack *Lena Rose* searches for oysters under her sails. The story of the skipjack is about more than a type of boat that outlived its usefulness. The story of the skipjack is part of the larger story of the Chesapeake Bay. The skipjacks disappeared because the reason they existed disappeared. The decline in the oyster mirrors the decline in the quality of the Chesapeake Bay. That decline affects the lives of the more than 16 million people who live near it. H. L. Mencken said in 1940, "The Chesapeake Bay is an immense outdoor protein factory." Each year, the Chesapeake Bay Foundation, the largest environmental organization dedicated to one region, reports on the state of the bay. Their most recent report shows the health of this estuary, and the oyster population is worse than the previous year. The days of this estuary feeding the world are past. (Courtesy of the Chesapeake Bay Maritime Museum.)

BIBLIOGRAPHY

Brewington, M. V. *Chesapeake Bay Bugeyes*. Newport News, VA: The Mariners' Museum, 1941.

Burgess, Robert H. *Chesapeake Sailing Craft*. Cambridge, MD: Tidewater Publishers, 1975.

Chapelle, Howard I. *Notes on Chesapeake Bay Skipjacks*. St. Michaels, MD: unknown.

Horton, Tom. *An Island Out of Time*. New York: Vintage Books, 1997.

———. *Bay Country*. Baltimore, MD: Johns Hopkins University Press, 1987.

———. *Turning the Tide*. Washington, D.C.: Island Press, 2003.

Stranahan, Susan Q. *River of Dreams*. Baltimore, MD: Johns Hopkins University Press, 1993.

Vojtech, Pat. *Chesapeake Bay Skipjacks*. Centreville, MD: Tidewater Publishers, 1993.

Warner, William W. *Beautiful Swimmers: Watermen, Crabs, and the Chesapeake Bay*. Boston, MA: Little, Brown, 1976.

Whitehead, John Hurt. *The Watermen of the Chesapeake Bay*. Centreville, MD: Tidewater Publishers, 1987.

INDEX

ACROSS AMERICA, PEOPLE ARE DISCOVERING
SOMETHING WONDERFUL. *THEIR HERITAGE.*

Arcadia Publishing is the leading local history publisher in the United States. With more than 4,000 titles in print and hundreds of new titles released every year, Arcadia has extensive specialized experience chronicling the history of communities and celebrating America's hidden stories, bringing to life the people, places, and events from the past. To discover the history of other communities across the nation, please visit:

www.arcadiapublishing.com

Customized search tools allow you to find regional history books about the town where you grew up, the cities where your friends and family live, the town where your parents met, or even that retirement spot you've been dreaming about.